JOURNEY THROUGH THE SPANISH CIVIL WAR

The Hinterlands

Dispatches from a Yiddish War Reporter

JOURNEY THROUGH THE SPANISH CIVIL WAR

The Hinterlands
Dispatches from a Yiddish War Reporter

By S. L. Shneiderman

Translated by
Deborah A. Green, Esq.

Photographs by
David "Chim" Seymour

Journey through the Spanish Civil War
By S. L. Shneiderman
Translated by Deborah A. Green

White Goat Press, the Yiddish Book Center's imprint
Yiddish Book Center
Amherst, MA 01002
whitegoatpress.org

© 2024 by White Goat Press
© for the translation is held by Deborah A. Green
All rights reserved
Printed in the United States of America at The Studley Press, Dalton, MA
10 9 8 7 6 5 4 3 2 1

Paperback ISBN 979-8-9894524-4-6
Hardcover ISBN 979-8-9894524-5-3
Ebook ISBN 979-8-9894524-6-0

Library of Congress Control Number: 2024933914

Book and cover design by Michael Grinley

Cover photograph by David Seymour / Magnum Photos

Originally published in Yiddish by the Jewish Universal Library, Warsaw, 1938

*This book was made possible
with generous support from
Randy Lyanne and Jon Keith Hirschtick*

o–o–o–o–o

Introduction

In the summer of 1936, Shmuel Leyb Shneiderman, a 30-year-old journalist from Poland, arrived by train in the Spanish border town of Portbou en route to Barcelona. For the previous three years he had been living in Paris with his wife, Eileen, writing for the Yiddish and Polish-Jewish press. Before that he had lived in Warsaw, where he studied literature and journalism and published two volumes of poetry. But that fateful summer, upon hearing about the outbreak of war in July, there was only one place he wanted to be.

In the wake of World War II and the Holocaust, the significance of the Spanish Civil War is often overlooked. But while it was being waged between 1936 and 1939 it was a war of major consequence. In retrospect, it contains historic lessons for our time.

By the early 1930s, Spain was a deeply polarized country. Since 1923 it had been a military dictatorship. But in April 1931 its king, Alfonso XIII, bowed to popular pressure and called for municipal elections throughout the country. The results, which brought leftists and liberals to power in virtually every major city, prompted the government to resign and the king to flee the country. On April 14 a provisional government was established and the Second Spanish Republic was born.

vii

As in the United States, ultimate power in the Republic was vested in the Spanish people and their elected representatives. Many of the government's supporters referred to themselves as "Republicans." Although the new government initially had broad support and was returned to power in elections that June with a mandate to draft a new constitution, the radical reforms it quickly undertook earned it as many enemies as friends.

In its zeal to correct centuries of worker and peasant exploitation, the Republican government tolerated the burning of religious buildings by urban crowds and stripped the Church of its privileges. It permitted civil divorce; granted women civil rights almost equal to those of men; nationalized church property; and dissolved the Jesuit Order. The Spanish Catholic Church and the Vatican responded by instructing Roman Catholics throughout the world to reject the new government. These instructions were ignored by anti-clerical Spanish peasants and workers who had suffered too long under the Church's yoke, which they identified as that of the ruling class. But the radical changes instituted by the new government alienated many of the Catholic faithful who may have otherwise allied with the Republican cause.

The Spanish military, accustomed to pomp and power, faced humiliating restrictions. The Republican government forced the army's most senior officers to retire or transferred them to distant colonies. It curtailed the number of military officers and closed the General Military Academy in Zaragoza.

Land and labor reforms, including limited expropriations, enraged the entrenched landholding and employer classes, while being seen by many workers as not going far enough. At the same time, government crackdowns on workers' strikes convinced the revolutionary left that the new regime was no different than the old. A sporadic series of violent incidents that occurred throughout the country during the first years of the Second Republic further convinced both sides of their positions.

Divisions among the left during the elections in 1933 swung

the balance of power back toward the right. The next year saw the creation of the Falange Española de las Juntas de Ofensiva Nacional Sindicalista (Spanish Falange of the Councils of the National Syndicalist Offensive), a fascist political party that would play a major role in the coming civil war. Like other fascists, Falangists believed in authoritarian rule, the elimination of regional separatism, and the use of violence to regenerate Spain, while opposing communism, democracy, and liberalism. The same year Communists and members of the Spanish Socialist Workers' Party (PSOE) launched a violent uprising, killing policemen, priests, and civilians, and taking over the center of the province of Asturias, before being put down by the military. In 1935, following a series of crises, President Niceto Alcalá-Zamora called for another election.

Eager not to repeat the mistakes of 1933, for the 1936 election Republican supporters from various left-leaning political parties joined together in a "Popular Front." The Popular Front was a political concept created and fostered by the Comintern, an international communist organization that was outwardly independent, but was in fact controlled by the Soviet Union. At this time its overt purpose was to prevent the further spread of fascism, but its covert purpose was to promote the eventual spread of Soviet-style communism. Spain's Popular Front was comprised of socialists and anarchists, often poor and semi-literate workers and peasants, pro- and anti-Stalin communists, and more moderate left-wing parties. Opposing them were the right-wing forces, who during the ensuing civil war would call themselves "Nationalists." They were comprised of a coalition of Falangists, monarchists, Catholic conservatives, traditionalists, and more than a few disillusioned ex-Republicans.

The 1936 elections were a win for the Republicans and the Popular Front, albeit by a margin of only one percent. Although the general election vote was split almost evenly, the new Republican government took its victory as a mandate. Their actions

brought a simmering political situation to a rapid boil.

Leftists took to the streets, freeing political prisoners and burning churches. Hundreds of thousands of hectares of land were seized by peasants from landowners, with tacit permission from the government. Workers throughout the country went on strike, demanding better pay and working conditions. Some on the left openly planned to transform the country into a socialist republic allied with the Soviet Union. But many in the upper classes had learned the lessons of the Russian Revolution and removed the bulk of their portable wealth from Spain before it could be nationalized. The economy toppled. On the streets, violence and anarchy reigned. The radical right, convinced that the new government could not be constrained by normal political processes, plotted a coup with military and civilian support. Five months later, important sectors of the military revolted and announced they were taking control.

The plotters anticipated a quick but bloody victory, since they were better prepared and far more united than the left. They expected the newly elected Republican government to admit defeat, as other administrations had done under similar circumstances.

In fact, Spain's Popular Front was not prepared to counter the right-wing attack and could not agree on a unified strategy. The anarchists and the Partido Obrero de Unificación Marxista (The Workers' Party of Marxist Unification, or POUM), believed the best response was revolution. They wanted to fight against the fascists and for the revolution simultaneously. In contrast, the PSOE, the Communist Party of Spain (PCE), and other parties loyal to the Republican government wanted to unite behind the Popular Front and first win the war against fascism. Only then would they complete the revolution. This schism caused many internecine battles, significantly weakening the government.

Further complicating the situation was a spontaneous workers' social revolution that began at the same time as the right-wing insurrection. The result was widespread implementation of

anarchist and communist ideas. This revolution continued for several years, primarily in Catalonia, Aragon, Andalusia, and parts of Valencia, where workers collectivized and managed businesses and agriculture, usually against the previous owners' wishes, creating additional chaos for the Republican government. The poor and disenfranchised believed their government wasn't doing enough for them; the government believed it had to rein in the revolution, at least until the Nationalists were defeated.

Yet the Spanish masses, with outdated equipment and minimal military training, fought boldly. They stormed the armories, grabbed weapons, and defended their cities and elected government. Consequently, the Nationalists failed to take any major cities except for Seville. What was mistakenly calculated to be a quick coup turned into a brutal civil war.

As members of the League of Nations, the world's democracies should have come to the Spanish government's assistance. They chose not to. Their rationale was simple and cold-blooded. They had no interest in defending a leftist government which collectivized property and persecuted Catholics, even though it was democratically elected. They also wanted to avoid the expansion of the conflict. France, the only other country with a democratically elected Popular Front government, might have helped Spain. But the United Kingdom threatened that if she did so, Britain would not help if French intervention caused a wider war. Unwilling to put itself at risk and fearing its own civil war between right and left, France proposed that all nations enter a non-intervention pact and let Spain deal with its own problems. There should be no outside interference. France believed such a pact would benefit the Republicans, who retained the wealthiest parts of the Iberian Peninsula.

The international community agreed. Few were interested in engaging in another European conflict so soon after World War I. In the United States, Father Charles Coughlin, a popular Roman Catholic right-wing priest from Michigan, and Joseph P.

Kennedy, a powerful politician from Massachusetts and the father of future American president John F. Kennedy, threatened President Franklin Roosevelt that he would lose the "Catholic vote" if he supported Republican Spain.

Ultimately, France, the United Kingdom, the Soviet Union and forty smaller countries including Mexico signed the Pact, as did Germany and Italy. The United States also adopted a policy of non-intervention. But the fascist countries violated the pact within weeks of signing it, sending weapons, matériel, planes, and men to the Nationalists at the request of their leader, General Francisco Franco. The democracies either did nothing or actively discouraged aid from reaching the Republic. Although officially declining to help Spain, France often looked the other way when the Republic smuggled arms and volunteers into Spain over its southern border.

Ultimately, only the Soviet Union and Mexico supported Spain's Republican government. Mexico provided the Republican government with two million dollars in aid and matériel, including small arms and aircraft. It also permitted its citizens to fight for the Spanish Republic without consequences. Soviet aid did not come cheap. As surety, Stalin received six hundred million dollars in gold, the entire Spanish treasury. Poland, Greece, and Czechoslovakia also sold arms to the Republican government, albeit for financial rather than ideological reasons.

The Soviet Union continued to support the Republic, albeit at low levels, until the Spanish government's defeat in April 1939. Germany, the UK, France, and Italy signed the Munich Agreement on September 30, 1938, gifting Czechoslovakia's Sudetenland to Germany. After the Munich sell-out, Stalin realized that if the democracies refused to help Spain and Czechoslovakia, they would never protect the Soviet Union. Stalin soon made overtures to Germany, attempting to prevent, or at least delay, an attack. In a show of good faith to Hitler, Stalin withdrew Soviet aid from Spain, thus hastening Republican defeat. The Spanish government could not defeat Franco, who, despite the Non-In-

tervention Pact, continued to receive reinforcements from Germany and Italy, and Texaco oil from America.

On April 1, 1939, the Spanish Civil War ended in defeat for the Spanish Republic. On August 23, 1939, the Soviet Union and Germany, two bitter enemies, signed the Molotov-Ribbentrop Treaty of Non-Aggression. On September 1, Germany attacked Poland from the west. On September 17, the Soviet Union attacked Poland from the east. By October 8, 1939, Poland had been defeated.

Many historians consider Germany's attack on Poland the official start of World War II. Others argue that the Second World War truly began when Spanish generals mutinied against their government and the world's democracies did nothing. Many historians believe that the insurrection would have collapsed within months, if not weeks, if the democracies had prevented Germany and Italy from providing aid to the Nationalists. Other historians believe that if Franco's Nazi-supported insurrection had ended in defeat, the German generals who opposed Hitler could have removed him from office and prevented World War II. Unfortunately, the democracies permitted Germany and Italy to violate the Pact and continue supplying the Spanish fascists.

Three years later, when the war was officially over, half a million Spaniards were dead and a legitimate government had been overthrown. Worse, the democracies had taught the world a crucial lesson: the fascists could do as they please, violate treaties or bomb unarmed cities, and there would be few consequences.

o-o-o-o-o

If the world's democratic governments were content to let Spain's Republican government fight for survival on its own, their citizens were not all so passive. The Pact prohibited foreigners from coming to Spain's assistance. However, between thirty-five to forty-thousand people from fifty-three countries streamed into Spain to help the Republic. They would become

known as the International Brigades. Between six to eight thousand of them were Jews.

While leftists around the world supported the Republican cause, for Jews the war in Spain had special significance. Many of them viewed fascism as an existential threat. By 1936, the political ideology of right-wing populist governments and their "strong man" leaders had taken root in many parts of Europe. Antisemitism spread like a virus as political leaders gained popularity by inciting the masses against the mythical "Judeo-Bolshevik" enemy within and without.

In Germany, Jewish life was being obliterated. In Poland the government passed antisemitic laws, encouraged boycotts of Jewish businesses, and remained passive in the face of anti-Jewish violence and pogroms. Some Polish politicians advocated for the forced mass emigration of at least one million Polish Jews to Madagascar as a solution to Poland's "Jewish Problem."

In the United Kingdom, Sir Oswald Mosley's fascists promoted anti-communism, protectionism, and the liberation of Great Britain from foreigners "be they Hebrew or any other form of alien." They marched through Jewish neighborhoods, attempting to terrorize residents. The British government chose that moment to clamp down on Jewish immigration to Palestine, violating their own Balfour Declaration that pledged English support for a Jewish homeland.

The blue-shirted, pro-Nazi fascist party Solidarité Française, started by the perfume manufacturer François Coty, was dissolved by the French government in June 1936. Its members promptly turned to the Parti Populaire Français, France's most collaborationist, fascist, and antisemitic political party.

Fascism was making headway even in America. The State Department had closed its doors to most Eastern European and Italian immigrants in 1924—very few Jews were allowed into the country. Fritz Kuhn, leader of the German American Bund, dressed in Nazi regalia and aspired to be an American Führer. Fa-

ther Charles Coughlin's antisemitic broadcasts grew in popularity every week. The Silver Legion of America, better known as the Silver Shirts of Asheville, North Carolina, called for the expulsion of Jews and non-whites from the United States.

For many Jewish leftists the best response to rising antisemitism was to fight fascism on the battlefields of Spain. They fought in Spain to defeat Hitler; they understood that Hitler's threat to themselves and to their people was not limited to Germany.

Who were these Jewish volunteers? Many were communists or socialists. Some were Zionists. Others had no allegiance to any ideological movement. But all were anti-fascist. They knew that coming to Spain violated the Non-Intervention Pact and could in many nations subject them to loss of citizenship, rendering them stateless. They came anyway. Upon their arrival, they were assigned to different International Brigades, usually according to nationality, and served as shock troops for the Spanish Army. At least a quarter of these International Brigade volunteers would lose their lives on the battlefields of Spain.

<center>o-o-o-o-o</center>

For S. L. Shneiderman too, the conflict in Spain carried a Jewish dimension. Born on June 15, 1906 in Kazimierz Dolny, a small Polish town that was then part of the Russian Empire, Shneiderman received a traditional religious education before going on to study in Polish public schools. In 1925, at age 19, he moved to Warsaw to study journalism and literature at the Free Polish University and quickly found a place in the city's Yiddish literary community. He contributed to the literary journal *Literarishe bleter* (*Literary pages*) and published two volumes of poetry: *Gilderne Feygl* (*Golden Birds*) in 1927 and *Feyern in Shtot* (*Unrest in Town*) in 1932. Like much of his later reportage, his poetry showed compassion for the poor, the working class, and those left behind by industrial modernity. Shneiderman also translated

world literature into Yiddish, wrote songs for the Yiddish theater, and film criticism for *Film velt*, the first Yiddish film magazine. In 1933 he married Eileen (Hala) Szymin, the scion of a Warsaw publishing family who would also become his editor, researcher, and professional partner for the rest of his career. That year the couple moved to Paris, where Shneiderman earned his living as a correspondent for the Yiddish and Polish-Jewish press.

In the summer of 1936 Shneiderman was back in Poland, covering the Przytyk pogrom trial in Radom. This was only one of many pogroms that occurred in Poland during the 1930s. In Przytk, as in places like Grodno and Mińsk Mazowiecki, windows were smashed, household goods were destroyed, and Jews were maimed and killed. As Shneiderman sat in the Radom courthouse on that hot and steamy day, he heard the Polish prosecutor charge fourteen Jewish men with the crime of defending themselves against a mob of rampaging peasants.

When the Przytk charade ended, Shneiderman went to Krakow to report on a workers' strike that ended with the death of nineteen factory workers and the wounding of many others by the Polish police. Jewish leaders of the Polish Socialist Party were also named as defendants, charged with encouraging the strikers. On July 18, while the strikers' trial was pending, Shneiderman learned of the insurrection in Spain. He immediately telephoned his editors at *Haynt* (*Today*), a Yiddish newspaper, and *Nasz Przegląd* (*Our Review*), a Jewish Polish-language publication, and told them he would be going to cover the war.

Shneiderman arrived in Spain in August or September 1936 (his autobiographical notes contain contradicting dates), just weeks after the conflict began. Shortly after his arrival, eight more Yiddish newspapers hired him to write for them. Dozens of others reprinted his articles. As a result, he became the chief war correspondent for almost the entire Yiddish press.

Although Shneiderman carried credentials from all these papers, the most important document came from *Der veg* (*The*

Way), a tiny Mexican weekly with a circulation of only 1,000–1,500. This was partly because the letter was written in Spanish, but mainly because Mexico was the only country other than the Soviet Union actively supporting the Spanish Republic. The Mexican credentials gave Shneiderman access to every political party and government ministry in Spain.

The Shneidermans worked as a couple. S. L. crisscrossed every part of Spain not yet in fascist hands, reporting on the elation of victories won at the start of the war, and then watching as losses mounted, Republican territory shrank, and defeat became inevitable. Eileen stayed in Barcelona, where she kept Shneiderman's notes, typed and edited his stories, and managed the business end of his profession. Shneiderman's Yiddish was terse and to the point and he did not indulge in flowery language. But because Eileen edited his reportage, it is difficult to know whether the writing style was his or hers, although it's safe to assume Shneiderman approved the final product. Shneiderman's style also had to contend with limitations on article length. Allowed only so many words, he made the best use of each one.

The Shneidermans were accompanied by Eileen's brother, photographer David Seymour, better known as "Chim." Like Shneiderman, Chim was drawn to the Republican struggle against fascism. He was already considered one of the world's best photojournalists; at the time Chim was more famous than his two friends, Robert Capa and Henri Cartier-Bresson, who would also gain fame photographing the Spanish Civil War and with whom he would found the Magnum Photos agency in 1947. Unlike Capa, who preferred action photos, and Cartier-Bresson, who took candid pictures of his subjects when they were not aware they were being photographed, Chim's style reflected his quiet and intellectual personality. According to Chim biographer Carole Naggar, he preferred to depict the causes and consequences of war. His photographs reflected the quieter moments of a country in turmoil. This subtlety is visible in the photographs

Chim included in Shneiderman's book; they reveal the effect of the war on the lives of the Spanish people.

Like all professional journalists, Shneiderman reported the news and the facts. Unlike other Yiddish reporters who ultimately made their way to Spain, he did not play favorites. He writes of the callous disregard by the Republican government for the families of International Brigade volunteers, but also describes Republican improvements to the lives of the Spanish working class. Although not permitted into Franco-controlled Spain, he reported on the heartache suffered by people on the "other side," as well in Republican held territory. Throughout, he shows sympathy for the plight of former factory and land owners whose property was confiscated.

Upon his arrival in Spain Shneiderman described his vetting by government officials, and how his travels throughout the country were arranged and overseen by communist minders. Shneiderman protected his sources, omitting their surnames or referring to them by their pseudonyms or initials. The Soviet purges and show trials had already begun in Moscow, and Shneiderman knew he was being watched. A Soviet bullet to the head in the middle of the night was not unheard of.

Shneiderman's ability to skirt censorship rules and propaganda improved the longer he remained in Spain. His reportage became even more vigorous. So too his anger and disillusionment with the appeasement strategies of the world's democracies and concomitant Spanish corruption becomes more apparent as time goes on. Only in the chapter titled "Sojourn in Catalonia" does Shneiderman's reporting become somewhat disingenuous—albeit necessarily, if he wanted to continue reporting on the war. In that article he heaped praise on Jaume "Met" Miravitlles, the director of Barcelona's propaganda commissariat. Miravitlles's job was to oversee foreign journalists in Spain. Shneiderman called him a "godsend," and described him as "a young revolutionary in a red sweater and button-down shirt, bleary-eyed, un-

shaven, working without pause." Shneiderman then informed his readership that Miravitlles provided his vehicles, scheduled his activities, and arranged for his travel passes. Readers were left to reach their own conclusions.

Shneiderman was not so much interested in the war's politics, however, as he was in how the war affected the civilian population. He was a left-wing Zionist but did not inform his readership of his personal politics, nor did he engage in propaganda. (I only learned of Shneiderman's feelings about communism from the articles he wrote for the *Forverts* newspaper in the 1970s.) His articles describe the day-to-day struggles of the people caught up in this worst kind of war, a civil war where a brother might inform on you, or a lifelong friend might kill you.

Shneiderman's readers shared a powerful interest in the Spanish Civil War with the rest of the world. Jewish concern, however, was based on factors other than just the battle between fascists and anti-fascists.

As early as 1935, Ze'ev Jabotinsky, a Russian-Jewish right-wing Zionist, pleaded with Polish Jews to save themselves from certain death. He begged them to emigrate to Palestine, while there was still time. In a speech in Warsaw in 1938, he said:

> For the past three years I have been appealing to you, Polish Jews, who are the glory of world Jewry. I have ceaselessly warned you that the catastrophe is approaching . . . You do not see the volcano which will soon erupt with the fire of your destruction. The vision before me is terrifying. Time is running out for you to be saved. I understand it is difficult for you to see, because you are concerned with your everyday worries . . .

By 1936, Hitler had been in power for three years. The American journalist John Gunther wrote in January of that year: "This is the age of great dictatorial leaders. Millions depend for life or

xix

death on the will of Hitler, Mussolini, and Stalin." Shneiderman understood this. Having felt the sting of Poland's antisemitism himself, Shneiderman's articles pulsated with the need to find a haven for his people. Great Britain had already locked the doors to Mandate Palestine. The United States had effectively ended most East European immigration in 1924. As if he knew a refuge would soon be necessary, Shneiderman asked if Spain would accept Jews into the country wherever he went and with whomever he spoke.

<center>o-o-o-o-o</center>

Shneiderman was a young reporter when he compiled *Krig in shpanyen*, based on his Yiddish newspaper articles. Volume I, which was published in 1938, describes his experiences in Aragon, Bilbao, Madrid, and other front-line cities, as well as his journeys through towns, villages, and battlefields and his encounters with the people living and fighting there. Volume II, which described Jewish participation in the International Brigades, was lost just days before or after the start of World War II, destroyed either by Polish government censors or the Nazis.

Shneiderman's book is far from the only one to describe the Spanish Civil War. Writers and historians such as Stanley Payne, Gabriel Jackson, Antony Beevor, Henry Buckley, George Orwell, Paul Preston, Hugh Thomas, Giles Tremlett, and others have devoted much of their professional lives to studying this war. They have written about its causes and history in depth. Their books provide a much deeper explanation than this brief overview. *Journey*, however, stands apart from those books. Shneiderman braided the lives and struggles of the Spanish peasants and workers with those of the Jews in Poland and elsewhere, making the Spanish troubles relatable to those of his Jewish readership. In his dispatches from Spain, Shneiderman wrote with an intimacy that permits the reader to appreciate this dramatic period through the eyes of those who lived it.

Introduction to the 1938 Yiddish edition

S. L. Shneiderman's book consists of rich reportage, political analysis, description, and chronicle. It is written with passion, pain, and emotion. The sudden events, the kaleidoscopic changes to people and personae, the ancient historical face of the land and its legendary past compared to its current blood-soaked misery are put into perspective by the author. He writes with passion, even when the facts disgust him. His artistic style of storytelling has weight and importance.

Shneiderman spent a year traversing dangerous sectors of a seething Spain, embroiled in war and revolution. With the fate of the world's future hanging in the balance, he exhibited boldness in the face of danger, a watchful eye and an alert ear, and he skillfully sought out authentic information. This was an audacious undertaking for any young reporter but especially for Shneiderman, the first Jewish war correspondent in Spain.

Shneiderman traveled throughout Spain's picturesque byways and along the hills of vineyards drenched in multicolored hues; he conversed with the common folk who did not interrupt their work in the fields even though the enemy's bombers flew overhead; he stood shoulder to shoulder in foxholes with the soldiers of the People's Army; and he visited face to face with wounded

xxi

International Brigade fighters as they lay wounded in their hospital beds. He was equally at ease in the offices of Spain's president, ministers, military leaders, and authors. He visited a distant monastery built on the history of Jews forcibly converted to Catholicism under threat of exile or death. He went everywhere in his zeal to understand, take note, and enlighten.

But the main reason for this book is something more than what is shown here. This book is written with a sense of optimism and a deep belief in the goodness of humanity and in the ultimate victory of humanity over the forces of darkness. As horrifying as life may sometimes appear, it should not depress us but fill us with hope and inspiration, creating a vision of a better tomorrow.

—Shlomo Sheinberg, publisher

A Few Words from the Author

Even as these notes are being published, the war continues to rage in Spain. I have observed this war from its very beginning, when fighters still wearing workmen's caps, instead of military helmets, battled behind improvised barricades. I witnessed these workers' militias become a proper army.

I divided this book into two parts because this war is being fought in two parts. Part I deals only with the hinterlands, where the civilian population displays no less self-sacrifice and endurance than the soldiers fighting in the trenches.

Part II* describes my "voyage" to the front lines of Madrid, Bilbao, and Aragon, if driving over bombed roads and flying in the "company" of enemy pursuit planes may be called a "voyage." The war and the revolution are being fought simultaneously in Spain, and both are far from over. I have presented the Spanish tragedy as honestly as I could.

—S. L. Shneiderman, Paris, January 1938

*Part II was presumably published in Warsaw, Poland, just days before Germany invaded Poland in 1939. Unfortunately, the book has vanished, destroyed by either Polish government censors or the Nazis.

BARCELONA

I watched the sea shimmer blue and olive under the sun as the waves' white foam broke on the shoreline, then disappeared. Towering above me on rocky flats stood solitary fishermen's houses hewn from white stone, overlooking the ocean. Thick flocks of dazzling, silver-winged seagulls dove into the Spanish sea and then rose skyward in a synchronized dance. I would remember these seagulls once again when I saw silver-white fighter planes dive toward Spain's unprotected cities. But that would come later.

I pictured Spain as a massive, bloody battlefield. My first surprise came as my train emerged from the tunnel leading into the Spanish border town of Portbou. I had not expected the casual attitude of the people waiting on the platform. Some wore civilian clothes, others were in uniform, but all wore green or red-black military-style forage caps on their heads. No other passengers were on board—they were all waiting for me.

I stepped off the train, and my reception committee immediately ushered me into the station. Several searched my valise for contraband while others concerned themselves with my papers. They scrupulously read each word, then passed the documents

from hand to hand. One asked me about the purpose of my visit, while another wanted to know which newspapers I represented. Finally, a young blond man stepped forward and addressed me in guttural German laced with a strong Yiddish accent. Somehow I communicated to him that I spoke no German, and our conversation veered into French.

I seemed to be quite popular—every man present was clamoring to participate in my interrogation. Anarchists, Trotskyists, and representatives of the United Catalan Socialist Party cross-examined me. Finally the head of the border patrol, an enormous man with a messy blond mane, ended the questioning by stamping a government seal onto the letter I had obtained from the Spanish embassy in Paris. I believed the stamp would transform the letter into an official document, allowing me to move freely throughout Spain.

"Please pardon all these questions," the giant said by way of apology. "We've had some unsatisfactory experiences with foreign journalists, and we need to be careful." He handed my papers back to me, and I assured him I understood his caution. An armed guard then led me into the station's waiting room.

The next train to Barcelona was not due for an hour, so I helped myself to coffee and took stock of my surroundings. It was impossible to ignore the immense posters pasted on every available vertical surface in the station. Two of them especially caught my attention. The first depicted a swastika being crushed under a peasant's canvas sandal; the other celebrated the Spanish women who fought on the barricades during the first days of the insurrection. As I wandered about the station, my guard stayed close. When my train finally arrived, he stepped on and stayed with me until we reached Barcelona.

Peasants, workers, and militiamen got on and off the train at every stop; some traveled with rifles slung over their shoulders, others with just a revolver at the hip. Everyone was on the move, going somewhere. The second-class benches soon filled

with people who had formerly traveled third class. At one time in Spain, the third-class carriage was always empty because the current crop of third-class passengers only traveled by foot.

Women were everywhere, old, young, some with children, others without, jamming the corridors, carrying foodstuffs to provisioning centers. Most passengers wore civilian clothes, but as at the Portbou train station, their headgear proudly announced their political affiliations: red and black emblems on anarchist caps, a red star on the hats of the United Socialist Party members.

Although it was late autumn, a hot wind rushed into the train through open windows, and the heat made it feel like midsummer. I spent the time speaking in French with my travel companions. Most had emigrated to France because there was no work to be had in their homelands. Now they were in Spain, hoping to find work in Catalunya or to join the Spanish militia.

Many of my fellow passengers mistook me for a Frenchman, hurling complaints at me from all sides. Why won't Leon Blum, the French prime minister, allow arms shipments to enter Spain? A militiaman returning from the Malaga front showed me his large, old-fashioned Nagant M1895 pistol while shouting at me. "Hundreds of our militiamen were armed with only a revolver. There wasn't a single rifle among us!"

I was relieved when a young, elegantly dressed couple entered our carriage at Girona and positioned themselves between the other passengers and me. He was blond and she a tawny brunette; his French was fluent and she spoke nothing but Spanish. He said he was a German Jew and the pretty Spanish lady with him was his bride of just a few days. The young man told me he was originally from Alexanderplatz in Berlin. He and his father left Germany as soon as Hitler came to power, and he was now teaching at a lyceum in Girona. His father, he said with pride, was now an important man in Barcelona's growing Jewish community. My conversation with him dispelled my last assumptions about Spain.

JOURNEY THROUGH THE SPANISH CIVIL WAR

o–o–o–o–o

The train pulled into Barcelona at seven p.m. It was already dark, and I could see the city's twinkling streetlights through the train's windows. It looked like Paris. My militiaman companion, who had spent the entire trip hovering over me, moved even closer and shouldered his rifle. He led me into passport control, where once again my passport was studied. Having passed inspection, I was delivered to yet another militiaman, who drove me to a government office, where my papers were once more reviewed and stamped. Finally I was released onto the streets of Barcelona.

Dinner was being served by the time I reached my hotel. The maître d' showed me to a richly appointed table laden with platters of fruit, carafes of wine, and sparkling dinnerware. Waiters in immaculate white jackets attended to my every need—I was stunned. The only hint of revolution was the enormous machine guns propped throughout the room. They leaned against their militiamen owners, who shared tables with stylishly coiffed ladies and elegantly dressed gentlemen. The dining room's open windows allowed the tinny voice of a radio announcer to drift into the room from an adjacent house. I understood not a word.

Despite my exhaustion, my curiosity would not allow me to retire after I finished my meal. I was both restless and curious about life in this city that had suppressed a military coup. What other surprises would I find here? It was ten p.m., but Barcelona still dazzled, its brilliant neon signs gleaming from storefronts. I had thought this kind of display existed only on the Paris boulevards.

I wandered into the street to explore. The city was awash in flags; banners in brilliant hues fluttered on luxury automobiles as they sped through the city. Green trams and multidecker buses flashed by, and ministry vehicles moved even faster than the trams. Young people and armed men and women rushed past me, the women in khaki trousers paired with green linen blous-

es. Red-painted lips, perfectly groomed eyebrows, and over-the-shoulder short-barreled rifles completed the women's ensembles.

Traffic was snarled on Plaza Catalunya, where the city's most luxurious hotel, the Hotel Colón, stood guard. Originally confiscated by Franco's Nationalists, it was now headquarters for PSUC, the *Partido Socialista Unificado de Catalunya,* the United Catalan Socialist Party.

As in Paris, cafés poured into the streets, and finding an empty seat, let alone an empty table, was impossible—the militia had commandeered them all. The tension was palpable. Newsboys hawked the latest edition of *La Noche* as cheers erupted from noisy cafés. People were celebrating the news blaring from loudspeakers that Franco had lost the town of San Martin de Valdeiglesias, and it was back in Republican hands.

It was after midnight, but the streets remained raucous. Newly appointed leaders sat in the crowded cafés drinking coffee. Trucks streamed into the city from all directions, bringing a myriad of vegetables, fruit, and other food. Posters tacked to the walls and kiosks advertised every kind of event, including a public gathering marking the twenty-seventh year since the murder of Francisco Ferrer, the architect of Spain's Modern School movement. Newly liberated Catalunya was calling on its people to celebrate the memory of this great humanist who had been murdered by the Alfonists, the monarchists who were now under General Franco's leadership.

<center>○-○-○-○-○</center>

I was on my way to the Barcelona harbor to watch the *Tsirianin,* an 8,000-ton Soviet commercial vessel, make its way into port. It was bringing the first gift of food from the women of the Soviet Union to the wives and children of the Catalunyan militiamen. Las Ramblas, Barcelona's major artery, was filled with people strolling to the dock to welcome her.

Before the outbreak of hostilities, street commerce was forbidden. Street vendors scattered at the approach of local police. Now peddlers no longer climbed into the trees to hide but openly hawked their wares up and down the length of Las Ramblas. The war had given birth to a new Republican industry: scarves embossed with emblems of new political parties, pins painted with portraits of new leaders, and leather insignias for revolvers.

Passersby stopped on their way to the harbor to buy these souvenirs to commemorate the occasion. The rhythm and dance of these Spanish street peddlers were familiar to me—rapid speech punctuated by even more rapid hand gestures, inviting potential customers to examine the day's offerings. I might have been back in Kolomyya, Częstochowa, Lodz, or even Góra Kalwaria.

As I enjoyed my walk to the harbor, I noticed wind-tossed, black-framed photographs of people hanging from trees bordering the thoroughfare. Beribboned wreaths of withered flowers honoring these heroes lay under the trees.

On July 19 and 20, 1936, Las Ramblas was the scene of the bloodiest fighting. The fascists had barricaded themselves inside the Church of Santa Monica and machine-gunned the Barcelonans for hours. The images in the trees commemorated the exact spots where the Republican fighters had fallen defending their city. Like so many other churches, the fortified medieval sanctuary of Santa Monica was burned to the ground. The beautiful church portal was now, like everything else, covered by bricks and posters.

Several hundred thousand people gathered at the harbor. They grabbed any available seat to watch the Soviet ship sail into port. Those who could not reach the dock stood under the bronze columns honoring Christopher Columbus.

The harbor was crammed with Spanish and foreign cargo and passenger ships. Floating among them was a green Nazi battleship, its swastika flag flying above it. An Italian battleship

floated behind it. Both ships were allegedly there to protect the German and Italian consulates.

The *Tsirianin* lay far from the harbor, and hundreds of small boats sailed out to greet her. A few impatient onlookers and I took a small motor boat to the *Tsirianin* and stayed in it throughout the welcoming ceremony. Red and red-black flags from different organizations and military regiments waved their greetings in the wind; among them flew the flag of the Ilya Ehrenburg *centuria*.[1]

The *Tsirianin* finally docked, accompanied by hundreds of smaller vessels. The people shouted their welcome, and a cacophony of deafening whistles from the gathered boats joined them. It was late when the last of the crowd left the port, but celebrations continued in the streets far into the night. Barcelona was determined to show she was as good at celebrating victory as she was at fighting on the barricades. But as Barcelona celebrated, the enemy advanced, its discipline tightening. That same night, even as Barcelona and Catalunya waved their flags in triumph, the men of the Ilya Ehrenburg centuria donned their helmets in the Hotel Colón front courtyard and marched off to war on the Aragon front.

HOTEL COLÓN

The Hotel Colón reigns over Catalunya Plaza, Barcelona's most elegant neighborhood. It was once a playground for Aragonian aristocracy and for those honeymooning couples who could afford it; now its concrete walls are stippled with bullet holes and a cannonball is lodged firmly in its façade. But this once-fashionable hotel is now part of Spanish history.

Shaya Kinderman,[2] a Jewish tailor, joined other tailors fighting on the barricades. Shaya is short and timid looking, and nobody would take him for the hero he is, but he was the first to enter the hotel Colón with a Browning automatic in his hand. When I met Shaya, he was already a seasoned fighter and the soul of the Colón, his office a tiny room on the first floor. Shaya arrived in Barcelona in 1935 with his wife, child, and a sewing machine. Once in Barcelona, the man who had stitched trousers in Paris sweatshops created a salon and library.

Newly arrived volunteers from all corners of the world sought Shaya's advice. He spoke with them daily, listened patiently to their concerns, and talked plainly to them in French, German, and Yiddish, using the informal "you" as he would with a friend. The words he spoke came from his heart, and he became a

mentor to many of these volunteers, Madrid's future defenders.

o-o-o-o-o

I first met Hans Beimler, the head of the Thälmann centuria, in Shaya's little office. The Thälmann centuria was composed of German antifascist volunteers and was the first International Brigade. Beimler would later become head commissar of all the International Brigades. I also met Ludwig Renn, the famous author of *Krieg,* in Shaya's office. Renn was born a Saxon nobleman, became a committed communist, and was now chief of staff of the XI International Brigade (Thälmann Battalion) and the 35th Division. I would meet many others in that nondescript office who smuggled themselves across Europe's borders to offer their lives for Spain.

Shaya's work ethic was considered idiosyncratic by many Spaniards. He arrived early and stayed late. The Spaniards who worked with him were both impressed and confounded by Comrade Shaya's work habits—why would anyone arrive at work before 10 a.m. and fail to leave promptly at noon? Despite this bizarre behavior, Shaya had many admirers.

Paid ten pesetas per day, the same as the other militiamen, Shaya found it insufficient to support his family. So although his desk drawer was stuffed with an assortment of currencies, Shaya sold his old sewing machine in November 1936 to provide for his family.

One Sunday afternoon Shaya and I went to the railway station to greet the returning remnant of the Thälmann Battalion, which fought so valiantly on the Tardienta front. The soldiers' wives, especially the German women, carried flowers to welcome their men home. Once the train rolled to a stop, the women swarmed the doors as exhausted, bewhiskered, and disheveled soldiers dragged themselves out of the cars. Many of the women, vibrant bouquets still in their arms, stood still and waxen as their

men failed to appear. These same women marched back to the city with the rest of the battalion, proudly taking the place of their fallen men within the ranks.

The welcoming orchestra played "The Internationale" in their honor, and although the song had become tiresome after being heard on the Barcelona streets for so many weeks, that day it sounded fresh once more, although tinged with sadness. The music reflected the mood. The trumpets sobbed, the flutes whimpered, and the drums kept a melancholy cadence for the men who had been lost.

A radio station installed on the Hotel Colón's sixth floor broadcast multilanguage speeches and exhortations to the outside world daily, becoming a true Tower of Babel. Hand-written placards declaring *"Es necesitan donares de sang!"* were pasted onto the hotel's outer walls, beseeching Spanish citizens to donate blood to the wounded volunteers risking their lives for the Spanish cause. Hundreds donated blood to these foreign volunteers.

Military traffic between Madrid and Barcelona was heavy. Every day newly arrived volunteers left Barcelona for Madrid and every day the bodies of leaders and political commissars killed in Madrid were returned to Barcelona. The funerals for those men turned into massive demonstrations.

THE BULLFIGHT

Every political party used propaganda to denigrate its opponents, but in no city did poster fever rage as fiercely as it did in Barcelona. No municipal building was safe—even the marble facades of luxurious palaces were not spared. The posters came in different sizes, but the most impressive were the lavish, color-saturated advertisements for the Sunday bullfights. Those posters covered entire building walls, each layered over the previous week's posters. They drew everyone's attention, including my own.

While waiting for my driver (a young typesetter who was chauffeuring me around Barcelona's old quarter), a certain poster caught my eye. I was transfixed by it. It depicted a slim matador, a pink cape slung over his shoulder, standing next to an infuriated bull, its maw misted with blood. The caption underneath read *"Extraordinario Corrida de Toros a Beneficia de la Cruz Roja Espanola de Barcelona"* ("Extraordinary Bullfight to Benefit the Spanish Red Cross of Barcelona"). Not only had the Republic not banned bullfighting, it was exploiting it.

The typesetter saw me examining the poster. Removing his military cap, he approached me. "The bullfight is too much a part of Spanish culture for it to be eliminated now. The tradi-

tion won't last too much longer," he said, fidgeting with his cap. "The true beauty of these fights vanished a long time ago. These bullfighting rings will become circus grounds soon. That is why I suggest you attend one, because these are the last of them."

The following Sunday I prepared to attend my first bullfight. I didn't anticipate a problem getting there, as most trams, buses, and metro stations announced their destination as *"Plaza de Toros Monumental"* (the bullfight arena). By 2 p.m. it was impossible to find an empty seat on any vehicle headed there. Eighty thousand people waited to enter an arena built to seat forty thousand. Among them were many militiamen who could not have afforded the price of admission before the war. Now they were being paid ten pesetas per day and could afford to treat themselves.

People crammed the building from the ground floor up to the sixth; even the corridors were jammed. Filled with sixty thousand people, the arena could hold no more. The others had no choice but to remain outside.

As at political meetings, "The Internationale" signaled the beginning of the corrida, the bullfight. The crowd stood and raised their fists in salute as the bullfighters corps marched into the ring. First came the toreros, the bullfighters, wearing scarves embroidered in gold and silver, pink socks, and black berets adorned with tiny black braids; the mounted picadores and the banderillas, those bullfighters whose job it was to taunt the bulls, swaggered in, red capes thrown over their shoulders. Three white horses followed, dragging an already gored bull into the arena.

The procession circled the enclosure once and departed. A young man wearing a militiaman's uniform and riding a black horse took their place. In the past, this man would have been dressed as an American cowboy, but now the most honorable uniform was that of a factory worker—green linen overalls.

The rider flipped around on the horse, rode it backward, and slipped on and off its back as it galloped around the field. It was

THE BULLFIGHT

a good show, but the crowd was restless. Only when the first bull entered the ring and rampaged around the arena did the crowd erupt into cheers. But suddenly the bull ended his mad chase and strolled into the center of the ring, where he stopped. He looked confused, surprised by the cheers that literally caused the walls of the building to tremble.

Four men with red capes approached the bull. The bull entangled itself in the banderilla's red cape each time a banderilla came close to being gored, making the mob cheer once more. Soon the crowd's enthusiastic shouts changed to protests and curses because the bull had developed other ideas.

A handsome fellow, the dark brown bull allowed his tormentors to chase him around the ring a few times but then decided to stand calmly in the middle of the stadium and look at the crowd with what appeared to be a grin on his face. The bull had fast become accustomed to all the red banners draped around the building, and the banderillas' capes no longer inflamed him. He seemed to bow to the audience.

The picador galloped up to the happy bull and stabbed him in the back. The bull retaliated by butting his head into the horse's belly, forcing the rider to fall to the ground. Ignoring the fallen picador, the bull turned his attention to the crowd once more, uninterested in fighting the banderillas. Although he was bleeding, the bull stood quietly, but the crowd was furious. They whistled and stomped and threw the little cushions provided to the audience members for their comfort as if they were hurling grenades at the picador and the banderillas. The picador's cowardly and unsportsmanlike behavior had ruined the event for the audience.

As soon as I sat down, I recognized the man sitting on my right as a compatriot. He confirmed my suspicions when the picador continued stabbing the bull. The man squeezed his fists in anger and screamed in Yiddish, "They're ruining my bull's hide!"

I stretched out my hand to this young man immediately,

greeting him with a heartfelt *"Sholem aleykhem!"* I soon learned he was a fur merchant from Warsaw. He purchased these bull hides and used them to make soles for shoes. He seemed to suffer as much as the bull each time the picador's sword pierced the bull's side. He blamed the bullfighter's incompetence on the revolution, adding it to his growing list of grievances.

"The true artists of the bullfight support Franco," he told me. "There are only bunglers left here. You should have seen the fights last year. The hides were beautiful, not tattered like now."

The matador entered the arena to rescue the situation and settle accounts with the unfortunate bull. Hiding his sword within a red cloth, he fluttered the cloth before the bull's eyes. The bull moved toward the cloth and the crowd regained its enthusiasm. They showered the matador with gifts of pencils, fountain pens, notebooks, and more red-black and red handkerchiefs, the prior insult to the bull forgotten by everyone, except perhaps the bull.

Two agile banderillas jumped at the bull, each piercing its neck with two spears wrapped in colorful paper. Blood spurting from his wounds, the injured animal chased his torturers. The matador leaped toward the bull and, with one blow, rammed his sword into the bull's neck.

I instinctively covered my face, unable to watch any further, but the crowd roared. The bull stood, the sword in his back, his head shaking from side to side, then fell onto his forelegs. The matador approached the bull and withdrew the blood-covered sword, wrapping it in red cloth. The bull was in its death throes when three white horses, golden harnesses gleaming, galloped into the ring. A crossbar was placed behind the bull's horns, and the horses dragged him from the arena.

Once more the orchestra played "The Internationale," and once more the crowd stood and sang its opening lines: *Arriba parias de la tierra . . .*

I turned to the elderly militiaman sitting on my left and ex-

THE BULLFIGHT

pressed my shock that, despite the war, the government still allowed the bloody display I had just witnessed. I told him it was incomprehensible to me that while human blood was being shed on every Spanish street, Spaniards still had an appetite for a bull's blood. The man was astonished. His anger barely under control, he growled, "Are your boxing matches any better? Is it acceptable to watch people lose their teeth or have their eyes gouged out?"

I asked whether these bullfights were still a feature in fascist-held provinces.

"No," he said. "Franco uses the bullfighting arenas as slaughterhouses for antifascists. The Badajoz fascist headquarters ordered all antifascists to be brought to the bullring. They crammed six hundred men into the arena and machine-gunned them. That's the entertainment being provided by Franco in the bullrings."

I took my seat while a second bull, much wilder than the first, ran into the arena. The crowd no longer protested when the bull fought back. The applause was thunderous. "Bravo!" echoed through the stadium. Ten minutes later, the bull lay dead in the dirt, and the white horses pranced in once more.

The program listed ten bulls, but I'd seen enough. My neighbor ridiculed my sensitivity and tried to convince me to stay longer, but I saw no point. Outside, on the elegant Paseo de Gracia Boulevard, a throng of people and a battalion of helmet-wearing motorcyclists followed a cortege of black armored cars moving down the street toward me. At the sight of this funeral procession, I forgot the horrors of the bullring and saw only the tragic battlefields, the human corrida that this beautiful country had become.

o–o–o–o

The symbolic unification ceremony of the anarchist red-black banner and the socialist red banner graced the center of the bullring. A platoon of Republican militia added the gold-red national

flag to the other two flags. They represented the symbolic unification of Spain's antifascist groups. Flags and banners bearing slogans fluttered throughout the galleries, while the ever-present portraits of the toreadors peeked out from between them.

Over one hundred thousand people had forced themselves into the arena for the first joint meeting of Catalunya's two primary syndicalist organizations: the anarchist *Confederación Nacional de Trabajo* and the socialist *Unión General de Trabajadores*. The speeches would be broadcast throughout the city, but the people wanted to see and hear the live speeches and were willing to wait hours under the broiling sun to do so.

Hanging above the speaker's podium was a huge, plastic raised fist, under which Catalunya's most famous speakers addressed the crowd, their voices amplified by the ubiquitous loudspeakers. The speaker above my head was making grinding sounds, and I turned in fear every few minutes to assure myself we weren't being attacked by fascist bombers.

Juan Comorera, a socialist minister and Catalan nationalist who built his party into a major political force during the war while the socialists, Stalinists, Trotskyists, and anarcho-syndicalists battled among themselves, and Federica Montseny, the famous intellectual anarchist leader, minister of health, novelist, essayist, and one of the first female Western European ministers, repeated the same slogan to the crowd: "The workers' front is the victory front!" Montseny described how Spanish workers captured the insurrectionists' cannons with their bare hands, jumping on the big guns while the fascist officers were reloading. The crowd was boisterous. It reminded me of Bastille Day 1935 in Paris, when the French tricolor and the red socialist flag flew side by side.

Once the speeches ended, the flags that had been so symbolically joined in the arena were once more separated, and their respective followers were once more at odds. Catalunya remained divided. The danger of the battlefield was distant; the intoxica-

tion of the early days of the battle had not yet dissipated. The workers' parties preferred to devote their energies fighting each other for control rather than waste time preparing to face their common enemy. Catalunya remained divided as the enemy advanced on Madrid.

DEATH SENTENCE

The staccato rhythm of machine-gun fire fills Barcelona's streets all night, every night. Political scores are settled fast, neither side taking pity on the other. Newspapers use the same bloodless language as a police report, ticking off the names of people who have disappeared, their corpses found days later. Government meetings recess for a few moments to hold "speedy trials" and execute captured military men. The names of those men are also added to the long list of the dead.

Andreu Nin, Leon Trotsky's former secretary, the leader of the Trotskyists and the first Catalunyan justice minister, suggested that these "speedy trials" be renamed *Tribunales Populares*—People's Tribunals—to reduce vigilantism against members of the right wing who opposed the Republican government. The government provides the accused with defense counsel, and a judge and two members of each antifascist political party preside over the cases.

Nin was himself "disappeared," caught up in the revolution's relentless wave of terror. I remember spending an hour in conversation with him in his office, speaking of the unavoidable cruelty of every revolution. We spoke in Russian, and my command of

the language impressed him. Taking advantage of the situation, I convinced him to provide me with a visitor's pass, allowing me to attend a People's Tribunal, so I could observe the conduct of these trials on the *Uruguay*, a prison ship. Before issuing me the pass, Nin said, "We don't allow most foreign journalists to board the *Uruguay*. Only the worst cases are heard on that ship. These prisoners are Spanish officers who fired cannons and mortars at peaceful, defenseless people. No foreign journalists suffered in these attacks; they only see the result—people are condemned to death. These reporters did not see innocent blood being shed, so they succumb to a natural sympathy for the prisoners."

I keep Nin's admonition in mind as the heavy-set clerk of the high court examines my pass. He records my name and, with what seems like sincere regret, reminds me several times that I must be at the dock by 9 a.m. the next morning. For a Spaniard, being anywhere at 9 a.m. is a true sacrifice. I was surprised by the punctuality of the tribunal's judges, lawyers, witnesses, and war correspondents from the Barcelona press gathered at the Columbus Monument waiting to be ferried to the red-painted *Uruguay*.

The chief justice is an old man wearing a beret. The other judges are leaders of Spain's Popular Front, which is composed of left-wing parties, the working classes, and those members of the bourgeoisie who oppose fascism. Some of these newly minted judges were shoemakers in Paris, but they now wear uniforms and revolvers. The lawyers are in suits, but no one wears a tie.

The *Uruguay* is anchored far from port. We approach her in a motorboat. Once, long ago, this ship cruised from Barcelona to Buenos Aires carrying "live cargo": girls being trafficked from Romania and Poland. She then served as a military courtroom, and its grand ballroom now serves as the people's courtroom.

Tall iron railings surround the two upper decks. The lower cabins hold four hundred prisoners awaiting trial; among them are fascist officers, German spies, and four priests. A large painting of a couple sitting beneath a fig tree, a copy of Goya's famous

work, hangs above the judges' bench. The judges are respectful to the men on trial. The chief justice advises the defendants of the charges against them; they all deny their guilt. They are permitted to smoke cigarettes, and court officers provide them with glasses of water.

The trial begins, but none of the accused shows any unease. Each defendant claims to be innocent and believes he will be exonerated. Their attorneys provide them with a good defense and portray them sympathetically. As the lawyers rattle on, I look through a porthole. The air is crystalline, the sun is shining, and the sky is cloudless; seagulls fly over the ocean's blue waves in search of their next meal. No death sentence can possibly be issued on a day such as this.

I turn back to the proceedings, watching as witnesses for both the accused and the prosecution are sworn in. Rank-and-file soldiers testify for the prosecution; decommissioned officers who remained neutral during the attack testify for the defense.

"Did you fire on the Republican Guard and on government police forces?" the prosecutor asks.

"We were only following orders," answers a defendant.

The prosecutor continues his interrogation, methodically shredding each defendant's prepared responses. The prosecuting attorney presents his version of the events of July 19, 1936, as if in a film. He reminds these fascist officers and sympathizers of the day they transformed the vibrant city of Barcelona into a vast, blood-covered battlefield. He describes how they fired upon Barcelona's defenseless civilian population from the safety of Artillery Park.

He speaks of the munitions factory director, also a defendant, who refused to distribute weapons to the police and, together with his two assistants, locked themselves into the reinforced main warehouse as they waited as the unarmed population was murdered in the streets. He describes how the workers finally breached the warehouse doors that night, grabbed the weapons,

and arrested the director and his companions.

The trial recesses at midday for lunch, and the judges, lawyers, and journalists take their meal in the old but still elegant ship's dining room. Green olives, the traditional food of peace, are served. The room hums with surprise at the courtroom's lack of formality and the attention paid by the chief justice to every word uttered by, or on behalf of, the defendants.

After lunch the courtroom is once again called to order and the proceedings continue into the late afternoon. As dusk grows nearer, the mood in the courtroom also darkens. The young and politically astute prosecutor's cross-examination is incisive, and the defense crumbles beneath it. Guilt is no longer in question, only the severity of the sentence.

The first defendant to break is a gray-haired lieutenant. His sobs verge on the edge of hysteria, and his sunken cheeks are aflame. The young sergeant sitting next to him looks catatonic as he stares off into the distance. The munitions director breaks into high-pitched giggles every few moments while his two assistant directors shield their faces with their hands. Only Captain Reilein listens attentively to the prosecutor's closing speech detailing the events of the "insurrection."

Reilein soon becomes the trial's focus. The soldiers, although witnesses for the prosecution, are sympathetic to him and emphasize his Republican leanings, but the prosecutor remains disdainful.

Addressing Reilein, he says, "You say you believe in democracy, so why didn't you, an officer of the Republican army, go out into the streets and defend the Republic? Why did you stay in Artillery Park with the fascist officers who were shooting at people in the streets, the people you swore to protect?"

Captain Reilein, looking more like a philosopher than a military officer, removes his horn-rimmed glasses and covers his eyes with his hand. Although the men under his command had shot at the civilian population, there was no evidence that Reilein had

taken part in the onslaught, unlike the other defendants who were caught committing treason.

The trial is reaching its climax, and the journalists pass notes, speculating on the outcome. The consensus is that seven death penalties will be issued that night. Some think there may be some hope for Captain Reilein, but Garcia Miranda, Reilein's most important defense witness, a former captain and a hero of the Aragon front, still hasn't appeared. According to the schedule, he should have already been called.

A tumult erupts among the growing crowd of spectators. The anxiously awaited Captain Garcia Miranda, filthy and disheveled, has arrived. Greeted enthusiastically by the crowd, he takes the stand. His testimony supports Captain Reilein's version of events, and the judges seem pleased. Finally the defendants are allowed to make personal pleas for leniency before judgment is rendered. These entreaties are the most difficult to hear.

The gray-haired officer is trembling, crying, and keeps asking, "Am I really to be shot? Am I really to be shot?"

The director of the munitions factory pleads, "But I am a socialist!" His two assistant directors maintain they are antifascist.

The Artillery Park commander begs for mercy on his children's behalf.

The young sergeant says nothing, unable to form words.

Captain Reilein, however, garners the sympathy of all those present with his succinct final statement. He says, "I don't fear death, but I would prefer to die in battle. I was wrong not to respond to the threat as my friend Garcia Miranda did, but please allow me to redeem myself."

The tribunal retires to deliberate, and the accused are returned to their cells. The room buzzes with the prospect of death sentence verdicts.

The tribunal returns to the courtroom within a half hour, but the defendants are not present. The chief justice recites the names of the six defendants sentenced to death. He pauses as

each name is called and asks the other members of the tribunal whether they agree with the sentence imposed. Each time there is a chorus of agreement.

"Captain Reilein—ten years imprisonment. Agreed?"

"Agreed!"

Although the benches are now empty, I can still see the ashen faces of the defendants and hear the crazed laughter and uncontrolled weeping of the two broken prisoners.

I run from the courtroom and onto the ship's deck, looking for some kind of relief. A salt-scented, caressing breeze is coming in on the evening sea as I swallow my first bitter pill of the Spanish revolution.

EL BARRIO CHINO

No Chinese people live in Barrio Chino, Barcelona's so-called Chinese Quarter. Close to the port, its streets are squalid, crooked, and dim. The sun does not shine here. Invalids sit in groups on cobblestone streets, their deformed limbs exposed as they hope for some coins from a sympathetic stranger. Laundry hangs from every window, rooftop to street. Organ grinders wail. Burros bray. Witches speak in tongues and sell magical herbs. The quarter is a nest of human desperation.

The barrio is Barcelona's oldest section, home to fishermen and sailors. Poverty is everywhere and permeates everything. This neighborhood once provided Barcelona's upper crust with the perverse entertainments it so enjoyed. Notorious homosexual nightclubs drew tourists from all over the world. But the first fighters to oppose the treasonous generals also came from this neighborhood. Once its people learned they could defeat the insurrectionists, they decided to take back their barrio. They destroyed the degenerate clubs that had ruined so many young lives and, although it was war, replaced them with the regional culture of Spain.

The Andalusian songs and dances heard and seen here evoke

an exotic mysticism. The black silken clothes of Andalusia are reminiscent of those once worn by Jews. In contrast, the brightly colored, heavily embroidered clothes of Aragon suggest those worn by Latvian peasants. The famed flamencos simmer with a Middle Eastern flavor. The melodies sound half Arabic, half Jewish. There is even a theory that flamenco music originated with the Jews of Spain, who stitched together these songs of lament throughout their years of wandering. Within the quarter there is a large wine cellar painted in beautiful colors. Wine is tapped directly from wooden wine barrels displayed in niches throughout the room. Exotic plants, palm fronds, red peppers, bunches of dried grapes, orange branches, and pomegranates hang from blackened wood ceiling beams. Singers come here to sing flamenco and other songs. Many of the international Brigade volunteers on leave also come here, singing songs in their mother tongues expressing their longing for home.

One thousand years ago, Judah Halevi, the great Spanish-born Jewish physician, poet, and philosopher, wrote a Hebrew psalm about the sea. He may even have sung this song on these same streets.

> *I have forgotten all my loved ones,*
> *I have left my own home . . .*

I once heard a militiaman weep a version of this song in this cellar. The song was translated into Yiddish by Hayim Nahman Bialik, the leading Hebrew and Yiddish poet. The Jewish soldier who sang the song was born in Riga and had been sent to France by his parents to study at the Grenoble Polytechnic. Without telling them of his plans, he abandoned his studies for the Spanish front. I found it romantic that in this ancient quarter of the former Jewish ghetto, this young Jewish volunteer sang a song that was written so long ago but still expressed his people's longing.

I was in this wine cellar when the Spanish "Marseillaise" was

born. A French militiaman had finished singing the entire French version of Rouget de Lisle's "La Marseillaise." As the applause was just beginning to die down, I noticed an Asturian militiaman sitting at a table close to mine. Despite the crowded room, he lumbered across the floor and made his way to the piano at the other end of the club.

"*U-hashe-pa! U-hashe-pa!*" the militiaman suddenly roared, his voice a deep and raw bass. The big man continued to bellow the initials for *Unión de Hermanos Proletarios*, the Union of Proletarian Brothers. The pianist kept time and banged on the piano's keys.

The Asturian coal miners had cried "*U-hashe-pa!*" as they flung packets of dynamite into coal mines. The acronym became the battle cry of the Asturian dynamiters who performed miracles on the Madrid front as they flung their bombs. The initials, when screamed in the heat of battle, crashed into each other and became one word: *Uhashepa!* This word also recalled the pain of the 1934 massacre in Oviedo, when General Franco's Moroccan troops slaughtered the striking Spanish miners and their families by the thousands.

The Asturian bellowed, and the people joined in: "*U-hashe-pa! U-hashe-pa!*" Soon all the wine cellar's patrons were bellowing "*U-hashe-pa! U-hashe-pa!*" As the giant militiaman returned to his seat, waves of crashing applause accompanied him. He fell into his chair, exhausted by emotion, his deep-set eyes misted with tears.

Every revolution has its songs and its anthems, and the Spanish Revolution's anthem will be "*U-hashe-pa!*," born of a slogan that wandered out of the trenches, found its way to a wine cellar, and united all workers in solidarity.

Soon afterward a woman stepped up to the pianist's stage and sang a heart-rending flamenco. All I heard was the Spanish "Marseillaise" echoing in my ears.

Perhaps this was the first time the word "*U-hashe-pa!*" was

set to music. Perhaps the French "Marseillaise" had also been created this way, by a piano player setting the poetry of de Lisle, a young revolutionary aristocrat, to music. But the French national anthem was written in a revolutionary aristocrat's private salon . . . the Spanish "Marseillaise" was born on an open field to the rhythm of exploding dynamite.

SOJOURN IN CATALUNYA

I was traveling with three other journalists, and we were required to get a valid permit from every political party in the region if we wanted to enter a town, rent a hotel room, buy lunch, or purchase gas for our car. Obtaining these permits was a bureaucratic nightmare, but fortunately, Jaume "Met" Miravitlles, director of Barcelona's Propaganda Commissariat, managed the foreign journalists in Spain and was a godsend. The commissariat arranged for our vehicle, scheduled every aspect of our activities, and helped us get the appropriate travel passes (although those passes didn't always satisfy the local officials). Sometimes "supplementary" documents had to be obtained from one or another political party.

A young revolutionary, Miravitlles was always in a red sweater and button-down shirt. He sat bleary-eyed and unshaven at an intricately carved desk and worked without pause. He greeted foreign delegations, journalists, and representatives, patiently answering all questions. In his spare moments he organized flights and trips throughout the region to showcase Catalunya's flourishing industry and refute allegations that Loyalists were destroying monuments.

To our unalloyed joy, Miravitlles assigned the finest vehicle that the Propaganda Commissariat had at its disposal to us, a

SOJOURN IN CATALUNYA

Hispano-Suiza, no doubt confiscated from some Catalunyan tycoon. We departed Barcelona on a sunny autumn morning, but the air smelled more like spring. We were on our way to Montserrat, the famous Spanish church built in the eleventh century and hidden amid a multipeaked mountain range. This wonderful little corner of nature was located only sixty kilometers from Barcelona.

I admired the beauty of this hardscrabble land as we drove through the countryside. The revolution had gifted this wild, uncultivated region to the Catalunyan peasants, and even though war surrounded them, they transformed the rocky wasteland into fertile soil. They plowed the land three hundred meters high, up to the mountaintop. But today was Sunday, a day of rest, and not a single peasant was to be seen in the fields.

En route to the church, we stopped to admire the former summer residence of King Alfonso XIII. It was now being used as a sanitarium for children, most sent here from Madrid. A magnificent garden surrounded the palace and masses of colorful flowers scented the air with a citrusy perfume.

The palace was built in 1923 from wealthy donors' "voluntary" contributions. The dedication of the palace was celebrated in true royal fashion, but the event ended in disaster. Trouble started when King Alfonso accepted the keys to his new residence from Barcelona's mayor. Unable to open the front door, the king called for a locksmith. The locksmith unlocked the front door, but the next door also failed to open. The king had to drag the locksmith through every room in the palace, including the bedrooms, because none of the keys fit any of the doors. The problems did not end there.

The following morning Alfonso, angry and annoyed, had to vacate his new palace because the water pipes broke, flooding the palace during the night. Expensive stucco fell from the ceilings and the royal bed was destroyed. In this manner the Catalunyan workers displayed their deep affection for their monarch.

The sanitarium's manager confided that the building was beset by constant problems and daily repairs were necessary. "Everything is falling off or breaking down. I have never seen such inferior workmanship."

Apparently, the Barcelona tycoons were also involved in this fiasco. "Go ahead, look," the manager said, tapping on the echoing walls, "it's a palace built of papier mâché." But he smiled. "These builders were short-sighted people. Didn't they know the king would never keep this palace?[3] Oh well, what's the point in complaining?" Under his breath he added, "Anarchist tricks . . . ," but he sounded more amused than annoyed.

We continued our trek up the mountain as the road corkscrewed through red-tinted hills. The Llobregat River, which irrigates the Catalunyan fields and drives the area's industries, roared beneath us. The Llobregat is wide and often overflows its fertile banks in the Pyrenees. Dense vegetation grows along the river's shores as do blocks of concrete factories, their turbine engines driven by the river's currents. The mighty river ultimately finds its way into Barcelona, but by then it is only a narrow stream, gently spilling into the canals that transport the water into far-distant fields and groves.

We eventually reached the Montserrat fields, where according to legend the image of the Virgin Mary appeared, bringing miracles. In the distance we saw the mountains that protect the church. Train tracks encircled them like a necklace.

Montserrat has intrigued travelers for centuries and was said to have inspired Wagner's *Parsifal* and Wilhelm of Humboldt's classic travel books. We decided to explore all of it, but first we wanted to satisfy our individual interests.

The total combined knowledge among the four of us about this unique Christian treasure was that Ignatius of Loyola founded the Jesuit Order at this monastery in the sixteenth century, and he was the order's first superior general. We knew nothing more. We were each curious about different aspects of the

church and wanted to be left alone to make our own discoveries. There were old manuscripts to be examined, illuminated Bibles to be read, and miracle-making icons to be inspected.

I was curious about the vaunted and valuable Jewish collections that were often sent out of the country to international exhibitions. One of my colleagues wrote for a major English newspaper and was interested in the Jewish relics as well. He was astonished when I quoted Torah verse to him in Hebrew, and he immediately requested I help him examine the artifacts.

<p style="text-align:center">o–o–o–o</p>

In July 1936 the Montserrat monks armed themselves with machine guns to defend themselves during the insurrection. However, a few days before the fighting reached them, they withdrew and fled to Saragosa. Only one monk remained, the church's head steward. He locked the doors to the archives, hid himself in the fields for two days, and returned only after Republican forces had occupied Montserrat. That same monk now stood before us, wearing a gray robe and canvas sandals. His black hair was combed smoothly back from his young and round face. Holding a fistful of keys in his hand, he opened the church doors for us to enter.

"The last Montserrat Benedictine monks were neither mystics nor hermits living in the wilderness. With the help of the finest printing presses imported from Chicago, they spent their days commenting on and illuminating religious books," he said. Waving us into the church, he asked, "Which would you gentlemen prefer to see first, the chapel or the nave?"

My colleagues and I were not interested in seeing either at the moment, as the expensive Benedictine wine known as Montserrat, made by the monastery's monks, was no less famous than the church.

"First we would like to partake in the pleasures of earthly

delights that Montserrat provides," I said. The monk sniffed at my comment, then led us into a large restaurant with a colorful, carved ceiling. Despite our invitation to join us for some wine, the monk refused. "The revolution has not compromised my religious beliefs. I do not drink wine," he informed us.

A waiter seated us and said, "We used to receive many foreign visitors each spring, but since the insurrection there is no more tourist trade because the right-wing press prints bizarre stories about unrest in Catalunya. English tourists are afraid to come, although last week a group of English and American priests did visit and determined that everything in Montserrat, including the museum, is as it was."

"What about the monks?" I asked.

"No one chased them away," said the waiter, as he inclined his head toward the monk waiting outside the restaurant, still unwilling to enter. "There's your best evidence."

After lunch our monk led us from the restaurant to the church. The contrast was striking. The church's facade was gothic, medieval standards flying from the ramparts, but inside everything was modern. There was no trace of either religion or mysticism.

President Azaña lived here, and his rooms were in the archbishop's former apartment. The president had just left for a government meeting in Valencia, so we were allowed to visit the salons. Rich, heavy silk covered the walls, and the furniture was intricately carved. Beethoven's Ninth Symphony rested in a green leather binder on the Bechstein piano in the music room. Among the original El Grecos and other depictions of religious subjects hung Morales's famous picture of an old, bearded man nursing at a young woman's breast. The monk assured us that all remained as it was; nothing had been touched in this church.

The monk tried to provide us with a detailed history of all the objects in the rooms, but we interrupted him with questions about the monastery's two inhabitants: himself and President Azaña. Carlos Areso, "our monk," as I referred to him, continued

SOJOURN IN CATALUNYA

his tour of the church as we badgered him with the same question: "Why didn't you leave with the other monks?"

Our monk responded simply and calmly each time, "I am a Basque," as if that answer was sufficient. He then continued telling us the details of President Azaña's life in Montserrat. "The president is an unusually industrious and modest person. He starts working in the library at 9 a.m. each morning. He visits the wounded militiamen in our hospital often."

Shepherding us through the massive salons, our monk continued his description of Azaña's schedule. "He usually has lunch on the grounds, goes to Barcelona to attend various political conferences, and when he returns continues working in his room until late at night."

I listened as the monk droned on, but I was far more interested in the floor-to-ceiling open bookcases lining every centimeter of wall space. There were over three hundred thousand rare, leather-bound manuscripts and books, in addition to the usual religious and secular books. There were books in every language, and more books were arriving daily, primarily from France. The smell of these ancient books, mixed with the smell of the old leather bindings, created an exotic perfume that made me think of incense and cattle. No filing system existed for these books, and they were shelved in the same order in which they arrived at the library. Ancient Talmudic tracts lived next to old Latin folios, and Hebrew-Dutch lexicons sat next to philological writings from Vilna's YIVO Institute for Jewish Research.

On our way to visit the monastery's printing presses, we passed President Azaña's desk. Two books lay open, Einstein's *Theory of Relativity* and Lion Feuchtwanger's *The Judean War: A Historical Novel of Josephus, Imperial Rome, and the Fall of Judea and the Second Temple.*

Of the two hundred monks who lived in Montserrat, half had worked in the publishing house. Before the insurrection, the monastery released a new book every week and serviced every

33

Spanish-speaking country in the world. The bindery, the editorial offices, the printing presses, and all necessary typefaces filled two large salons. The words *Loshn hakoydesh*, "The Holy Language," were inscribed on a plaque and hung above the case where the Hebrew typeface was stored.

All seemed frozen in time, as if the monks had just stepped out for a moment. Bound pages of Hebrew writing were still lying about on worktables; templates for new, illustrated Bibles were still in the printing presses. I skimmed the museum's aisles, searching for the Jewish section. My colleague from the English press was not impressed with the general archaeological exhibits, finding the three-thousand-year-old mummy napping on its bier "very young." He was also not especially interested in the embalmed crocodile, labeled in Latin as *Crocodylus* and in Hebrew as *levyosn*, the legendary sea creature of Jewish lore.

At the entry to the Jewish section of the museum, a large plastic map of Palestine covered half a wall. A mass of Jewish "antiques" and archaeological objects allegedly dating back to Moses's time were assembled under glass. Rose-colored jars held "stalks of manna sent from God." Next to them were "bricks kneaded by Jews when they were slaves in Egypt." More off-putting chronologically were the "collections of Jewish antiquities." Next to rare menorahs and illuminated scrolls were banal Rosh Hashanah greeting cards still being sold on Nalewki Street in Warsaw's Jewish neighborhood and in the Pletzl, Paris's Jewish quarter.

The greeting cards were colorful reproductions of Szmul Hirszenberg's paintings, clipped from the Hamburg *Israelitisches Familienblatt* magazine pages. There was also a collection of Jewish memorabilia: documents; seals inscribed with Hebrew letters that had once belonged to the Jewish finance ministers of ancient Spain; a precious collection of antique ceramics; gold bracelets engraved with Torah passages; and many silver platters with Yiddish inscriptions on them, such as *"Gut vokh!," "Gut shabes!,"* and

"Gut yor!"

I provided my English colleague with a lengthy explanation of the purpose of the beautiful little circumcision knives displayed under glass. With our monk's permission, I showed my colleague how to wrap tefillin, placing the two small leather boxes on my arm and my head. I also blew into the collection's large, yellow shofar, intoning short notes through the ram-horn instrument.

The monk, impressed by my knowledge of Jewish rituals, sidled up to me: "¿Es usted hebreo?" he asked in Spanish. He then cobbled together a few awkward Hebrew sentences to inform me that he had been to Jerusalem last April and while there witnessed an Arab attack on the Jews. "Have things calmed down in Palestine yet?" he asked, adding, "Several Benedictine monks hid Jewish families while I was at the Jerusalem church."

As we left the museum, we were shown the Montserrat visitor's book. His Majesty King Alfonso XIII had signed the book several times in several places, splaying his signature over the entire page. Next to the signature of the great French poet Paul Valéry—who once dedicated a few inspirational verses to the monks—was that of Alexander Kerensky, former president of the short-lived Russian Republic, dated May 9, 1933.

Although these signatures were of interest, the real surprise was Calvo Sotelo's signature. We all ripped out our notebooks because Sotelo's name was synonymous with the insurrection. As the king's finance minister, he was in line to be the next Spanish dictator. The Republican victory deprived him of that opportunity, so he set in motion the military insurrection in an attempt to reclaim what he believed was rightfully his. Franco took his place only because Sotelo was assassinated in Madrid several days before the July 19 rebellion in retaliation for the fascist murder of a high-ranking Republican officer.

Not only had Sotelo signed his name, but he had also proclaimed his political beliefs, writing, "I swear by Montserrat's

strength that as a Christian and as a patriot, I will always believe in God, and I will always love Spain." He signed it "José Calvo Sotelo, Finance Minister, May 16, 1928." What a find! The photographers among us could not snap their cameras fast enough.

His signature and message were a wonderful parting gift to my colleagues and me.

The ash-colored boulders of Montserrat glowed in the dwindling rays of the sun. We drove away through the cypress-lined roads of the church's parks, overlooking a lush green valley. Night fell fast. The only sound we heard was the fluttering of a Red Cross banner hung above the front door of a former hotel, now transformed into a military hospital. The war could not be evaded. It was everywhere, even among the naked stones of Montserrat.

COLLECTIVES AND COOPERATIVES

We followed a slow-moving funeral procession as we drove down the mountain. Wounded militiamen walked behind the horse-drawn hearse, arms in casts, heads bandaged, limping on crutches. We heard the drumming of the horse's iron shoes echo on the glistening asphalt road as the caravan curved right and we veered left.

A long mountain chain crowded with vineyards and wine cellars separates this fertile region of Catalunya from the fighting on the Aragon front. Catalunya's land and industry were collectivized within days after the insurrection was suppressed, eliminating private ownership of land and business. The anarchist syndicates that instituted these collectivization reforms in this part of Spain were successful because of existing conditions in the area—there had been a long history of multibranched cooperatives here, so the transition to collectivization did not create a problem.

Before inspecting the factories in Sabadell, our guide suggested we visit the local museum and textile school to better understand the development of the Sabadell industries. The museum was owned by Sabadell's textile industry and dated back to the fourteenth century. It showcased many types of velour, as well as a ninth-century loom and several spinning wheels of

the kind featured in fairy tales. An enormous chest held fabrics allegedly dating from the twelfth century. The oldest examples featured complex designs woven into brightly colored fabrics.

We left these medieval remnants and moved into a large, brightly lit building that held modern machines and a textile school. I noticed a half-completed portrait of Alcalá-Zamora, Spain's former president now in exile in Paris, still on the loom of one of the new electronic weaving machines.[4] The school's director was embarrassed by my "discovery." He explained that the students learned the art of weaving by using a portrait as a template, and the only available portrait was that of the former president. The director held himself blameless. The government had not yet provided him with a picture of President Azaña, and creating a new template was difficult and expensive, and the committee in charge of such things did not want to spend the money. Mumbling a few more words, he turned Zamora's picture over, and we continued our tour.

No trace remained of the actual medieval textile factories.

We then visited a winepress in the industrial town of Martorell, where we sampled different wines and liquors. The press's manager showed us massive, liquid-filled cisterns and explained the intricacies of mechanized wine distillation and the factory's history. It had been a collective prior to the revolution, so very little had changed. "We still have the same number of members, but we now have a lot more development opportunities available because the government-owned banks provide us with credit. In the past we had to deal with grape wholesalers or fruit-producing peasant groups directly. Now the agriculture syndicate is our supplier, so there is no more competition and prices have stabilized. We only need to deal with one customer, the local economic council. The council negotiates with the army's provisioning ministries and with the exporting agencies."

"How is production going? Are you producing less because of the war?" I asked.

COLLECTIVES AND COOPERATIVES

"Production is better than ever. The army buys a lot of our wine, and the public finds more opportunities to drink too. The factory now works three shifts, and unemployment is no longer a problem," the factory director said while filling our glasses with more wine.

"Are the factory profits divided like before?"

"Not yet. Our wages are 15 percent higher than before, but this difference is deposited into our collective factory bank account, and we can spend it only on necessary investments. No decisions have yet been made."

"Is it true that all the land in this area has been collectivized?"

"When the landowners ran off to join the fascists, the larger estates were nationalized. The Republican-owned estates are now controlled by the labor commission and the income is deposited into the federal bank. They tried to collectivize the smaller plots of land owned by some peasants, but that plan did not work out so well and has ended. Some collectivized land was returned to its former owners, but always for good reason.

"Collectivization brings good results to an industry that is technologically ready for a collectivized economy. Regarding land, particularly in Spain, where agriculture is still very primitive, it is impossible to collectivize the small plots of land into a collectivized whole all at once. For that to happen the entire region's agriculture would have to be mechanized. The war makes that impossible right now."

And, I thought to myself, *once the peasants finally got some land of their own, they would start another war before giving it up.*

"We are struggling with the required mechanical collectivization. We support collectivization if it's useful to those involved. We do not support concepts; the concepts must support us," our guide said as he ended the lecture on this philosophical note.

I asked him what party he belonged to and how politics affected the village.

"I belong to the *Unió de Rabassaires,* the same party as Pres-

39

ident Companys. The *Unió* is a left-leaning Republican party attractive to small landowners, and I sit on its economic council," he continued. "The anarchist syndicates have a great deal of influence over the agricultural workers, but their popularity is waning. It's being replaced by the United Socialist Party syndicate that opposes collectivizing the peasants' small plots."

The anarchists, excited by the success of collectivization, had tried to collectivize the tiny plots of land owned by the peasants who worked for the collectivized producers of luxury goods. The peasants were not pleased that their private land was going to be used for the benefit of all. They, and the political parties that supported them in their opposition to what they considered an ill-considered form of integral collectivization, opposed the anarchists.

We left the wine factory for a metallurgical factory in the same town. It now produced hand grenades instead of the plows it had previously manufactured. Like the winepress, this factory also worked three shifts per day and included a special group of volunteers who worked Saturday afternoons and Sunday mornings on the army's behalf.

As we made our way through the villages, we noticed that unlike a few months ago, there were no longer any young men in the bars. They were all in the army; their untouched leather botas hung on the walls. The boys were experts in squirting wine down their throats from these botas; they competed to see who could create the longest arc of wine from the bota to his mouth. My colleagues and I tried doing the same but sprayed wine all over ourselves. The old peasants, black kerchiefs on their heads, broke out laughing at our clumsiness. When they were done ridiculing us, they instructed us on the proper way to drink from a bota.

Our guide led us higher into the mountains to the town of Sant Sadurní, home to the champagne company. While Loyola had been busy establishing the Jesuit order on one side of Montserrat, Josef Raventós was busy establishing the Spanish Co-

dorníu champagne company on the other side.

The original wine cellar and wooden winepress were still there. Niches in the wall held bas-relief images of the Raventós family members who had enlarged the factory over the centuries. These niches were illuminated twenty-four hours a day. The new owners continued to leave these niche lights burning. The ambience was what we had expected to find at Montserrat, everything built in a churchlike, Gothic style, even the new underground supports.

At twelve kilometers long, these cellars held between ten and fifteen million bottles at any one time. We were told it took five years before a bottle of champagne was ready to be sold. During that time the bottles were moved ten times, each bottle transported from cellar to cellar, each cellar maintained at a specific temperature. Towers of bottles leaned against the cellar walls, and the older workers transported them to a different cellar twice a year.

The cellar corridors crisscrossed each other. Each corridor was named for a Christian saint or one of the former owners. These passages were now being renamed in honor of the factory workers who died fighting in the war. Spaniards were the primary consumers, although a small amount of Codorníu champagne was exported to Argentina and England. The Soviet Union had recently become the factory's newest customer.

The Codorníu owners escaped to Italy several days before the July 19 insurrection. Two days later the factory was back in production, managed by the company's workers. A company representative told us that one of the former owners, Juan de la Cierva, the famous engineer and inventor of the autogyro gyroplane,[5] was General Franco's head of aviation before he died in an airplane crash. This was his way of informing us that the factory's former owners were fascists and had been part of the insurrection.

When we asked our guide whether production had improved

since the factory takeover, he took umbrage. "All the workers know they work for their comrades at the front, who can now warm themselves with a little of the wine we produce while they are in the trenches. Also, wine is now Spain's biggest export. It's paid for in foreign currency, and foreign currency allows us to buy weapons. The workers know that by producing champagne, they are producing machine guns, cannons, and planes."

We continued through the cellars, and the towers of wine bottles now looked like pyramids of hand grenades to me. Our tour ended with our guide popping the cork on a bottle and pouring the white foam into crystal glasses. The hand grenades were once more bottles of champagne.

We spent the night in the Codorníu owner's abandoned villa. I could not sleep in the large fancy bed with its shiny, silken sheets. In the morning we were off once more, finally on our way to Sabadell. The asphalt highway glistened in the November sun. The harvested vines up on the hilltop looked as if they were made of gold. In the valley, the sky was stained a dark violet from the smoke emitted by the textile factory chimneys. Sabadell was Spain's version of Manchester, England, or Lodz, Poland, and it was running at full capacity.

Enormous palm trees shaded the city center. It had once been home to municipal offices but was now also housing the most important bureau of all: the supervisory office. That office oversaw the local collectivized and cooperative industries. It was also where we went to get the necessary permits to visit the wartime industrial factories. The former industrialists' palace now housed the current supervisor and secretariat.

Sabadell's mayor, a former textile worker, was the secretary general of the local PSUC syndicate. He introduced us to the factory's supervisor, a worker with the odd name of "Moysh," a Yiddish name. When Moysh heard I was from Poland, he rose from behind his luxurious desk and, keeping my hand clasped in his, questioned me at length about Lodz.

COLLECTIVES AND COOPERATIVES

He told me the main economic council and the respective workers' committees of every industrial branch regulated the prices. "The economic council supplies the factories with raw material, although the army will often supply its own. In those cases, the army pays only for labor.

"Although the work week is officially forty hours, the workers will often work longer when necessary. They sometimes work on Sunday, although that is the official day of rest. If no raw material is available, the factories shut down. The workers still receive their usual wages, including the recently authorized 15 percent pay increase."

Male textile workers receive an average salary of eighty pesetas for the week; female workers receive forty-five. When there is no work, women knit for the army: gloves, scarves, socks, and hats—everything is yellow, of course. The men look for day labor.

"We live by the principle that all must eat," the local workers' committee representative said.

Sabadell's fabrics were first woven in the eighth century. In the twelfth century, the king ordered all officers and officials to wear clothes made only of Sabadell fabric; clothing made from Indian fabric was forbidden. Sabadell has always been a modern city. Its telephone and telegraph lines were installed even before those of Berlin. On May 8, 1853, Sabadell converted to gas lamps, making it the second city in Spain and the fourth in all of Europe to do so.

Sabadell was once the center of Europe's most elegant fabrics. It supplied the world's most stylish and expensive fashions to celebrated Parisian couturiers such as Larsen and Voisin. Its factories now produce nothing other than fabric for the Republic's soldiers. The multihued luxury fabrics are gone; only dull yellow textiles remain.

Getting raw material is a serious problem for Spain's textile industry. If the war continues much longer, it will reach crisis levels. Spain once imported 30 percent of the raw material required

by its textile industry, but now all available foreign currency is used to purchase items needed for more pressing concerns.

"Tell our foreign friends to send us more rags," a committee member said with a smile.

Even the factory that manufactured beautiful automobiles now produces tanks painted the same khaki color as the Sabadell uniforms. Yellow, yellow, yellow, in the factories and on the harvested fields; the oppressive yellow of war is everywhere.

o-o-o-o-o

Sabadell's new factories are modern. There are no dull, cramped, red-brick factory buildings as exist in Lodz. Small groves of palm and olive trees surround the factories, which are located mainly on the city's outskirts. The walls are painted white, and despite the blazing sun, the factory courtyards and even the machine rooms are airy and spotless.

One half of Sabadell's eighty thousand citizens are employed by the textile industry, but there are none of the cramped workers' apartments typical of Lodz. In the neighborhood of Bałuty, Lodz's impoverished Jewish textile workers live and work in dilapidated buildings. Factories, warehouses, and open-air markets line the narrow streets, and the neglected sidewalks and gutters are often flooded. In Sabadell, the Spanish workers live in lovely three- and four-room homes. It is open to question whether the Spanish workers will keep their hard-won benefits. More than three thousand of Sabadell's textile workers are at the front. Each factory supports its group of fighters, their wives receiving their husband's full pay.

The factory committee representatives take pride in the collectives' production levels. They remain high even though there are no supervisors on the floor. The Sabadell workers have a sense of obligation and exercise self-discipline.

COLLECTIVES AND COOPERATIVES

o–o–o–o

We were curious about the fate of the former owners of the collectivized factories and asked about them. Our guide said, "Those who belonged to the *Falange* either left with the fascists or were 'exiled' to the next world. The ones who remained were not involved in politics or were Loyalists. If you would like, I can introduce you to such a former owner."

We got into our Hispano-Suiza, and after a ten-minute ride over a palm-lined roadway we stopped at a gold-glazed iron door decorated with an enamel shield bearing the name "Salardes."

"The factory's former owner lives here," our guide informed us as he rang the doorbell.

Someone opened the door, and we climbed up the marble steps and entered a beautiful, sun-filled room decorated with stained glass. The glass caught the light of the setting sun and created a rainbow effect throughout the room. Magnificent frescoes hung on the walls, the ceiling was finished in a rich stucco, and multicolored glass artwork lined both sides of the hallway. After being surrounded by so much drab yellow, the glassware's bright colors were a relief to the eye. If I did not know this was an old workers club, I would have thought it was a Protestant church transformed into a work camp.

A worker fetched the former owner, who was now a simple employee in the factory that was formerly his. He was a gray-haired and elegantly dressed gentleman and had an intelligent look about him. He carried himself with grace and asked how he might help us. My colleagues and I were suddenly tongue-tied and embarrassed, but after some polite conversation, we asked about his current role at the factory.

"The workers committee controls the factory," he said. "As before, I am the chief financial officer, and my brother is the director. Our late father built the factory, and we are his heirs. We continue to work just as before, and we still worry about how

well the company is doing, but the profits are no longer ours."

"Hasn't the factory been collectivized?"

"No, in my factory—"

He caught himself immediately, blushed a little, and then said, "Only ninety-six people work here. Automatic collectivization laws apply only to factories that employ at least one hundred workers. The workers decide whether a factory will be collectivized or whether it should continue to operate under the present arrangement."

He fell silent. One could sense him thinking of the reasons not to collectivize. After all, there were only ninety-six workers, not the full one hundred required for compulsory collectivization . . .

"How much are you paid?" I asked.

"One thousand pesetas per month. That's a bit more than the main factory engineer makes."

"How is the factory doing financially?"

"At the moment," said the former owner, "we work exclusively for the army; there are few customers who require quality goods right now. We still have enough fabric left to service our old Parisian customers for the next few months, but then it's over."

"Other than yourself, have any other factory owners remained in Sabadell?"

"Not all manufacturers are fascists."

"You're right," I said. "Freidrich Engels was also a manufacturer's son and managed his father's factory for a while."

"I know," said Mr. Salardes. "Our factory's archives contain a report about the elder Engels's trip to Sabadell."

We started back to Barcelona at twilight.

LLUIS COMPANYS, PRESIDENT OF CATALUNYA

The Catalunyan villagers and townspeople argued about many things, but one thing they all agreed on was the Catalunyan president, Lluis Companys.[6] Everyone—Loyalists, socialists, communists, even the most radical anarchists—respects him. Neither Francisco Largo Caballero, the prime minister of Spain and leader of both the Spanish Socialist Workers' Party (PSOE) and the Workers' General Union (UGT), nor Manuel Azaña, the president of the Spanish Republic, enjoyed the same level of popularity as Companys. The people considered him the one man capable of unifying all the disparate parties under the Republican flag in the event of a crisis.

It was Companys who opened the ammunition warehouses to the Loyalists, socialists, and anarchists on July 19 to defend against the traitorous generals who led military regiments into the streets. He armed the people and allowed them to defend themselves against the insurrectionists and save their republic.

In 1934, when Companys led a Catalan nationalist insurrection against the then-new government, the dictator Alejandro Lerroux imprisoned him on the floating prison ship *Uruguay*. A poster of President Companys peering out from behind bars is

still the most popular poster in Barcelona. It focuses on Companys's emaciated face and intense stare. He still looks the same; the only change is that his brow is more wrinkled and his hair is more gray.

o–o–o–o–o

We waited to see him in the reception area for three hours, surrounded by exquisitely carved furniture, crystal chandeliers, and deep armchairs. With nothing else to do, I examined the ancient battle scenes depicted in the frescoes on the walls. Every half hour the president's secretary peeked his head out of his office to say that the ministers' council's meeting was "running late" and assured us that at "any moment," "very shortly," and "quite soon" we would be received.

One of my colleagues discovered an old painting of the Binding of Isaac hanging in a corner. The picture portrayed the moment when Abraham, ready to slay Isaac, was stayed by an angel leading a lamb. The image was one of joy and gentleness, but behind the frescoed walls upon which it hung a heated debate raged. The country's leaders were discussing the war. As we eavesdropped, Companys suddenly appeared in the reception hall and waved us into a small room overwhelmed by an enormous desk. On the desk was a gold inkwell and a blue ostrich-quill pen. An unexploded aerial bomb manufactured by the Barcelona ammunition factory sat on a small pedestal nearby.

President Companys shook each of our hands.

"We're from the Yiddish press," I began the interview. "The entire Jewish world is nervously following the fate of Republican Spain."

"Please send my sincere regards to your readership. I am aware of their concern, and I know many Jews have moved to Spain, particularly Catalunya, these last few years. As some of our most loyal citizens, they joined the militia to defend their new

fatherland on the first day of the insurrection."

I was shocked. While President Companys was lauding the Jews of Spain, Jews are being accused of betrayal and desertion in Germany and in other even larger Jewish centers. I was struck by the irony of hearing these words of praise in the same palace where, five hundred years ago, the Inquisition issued decrees ordering the Jews of Barcelona, Tortosa, and the other Jewish Catalunyan communities to be burned at the stake.

Glancing out the president's office window I saw the gothic facade of the cathedral in El Call, Barcelona's ancient Jewish quarter, which still houses the Inquisition's instruments of torture. I turned back to the president and asked him about the possibility of Jewish immigration to Spain.

"The doors of my country and the doors of my heart are open to the Jews," he said.

I asked what he thought of the Republic's chances of winning the war. Leaning over his desk, he looked directly at me and said: "We will win this war because we fight for our rights, because we are self-sacrificing and heroic, because we must win this war, because we must succeed. The future of the entire democratic world depends on our victory."

I remembered why people considered Companys Barcelona's finest lawyer. Here was the man who defended the persecuted Catalunyan revolutionaries and anarchists throughout the years of monarchy and dictatorship. The man whose appearance in court heralded the coming emancipation of the Catalunyan people and threatened the reactionary regime.

As he continued speaking, Companys, the revolutionary activist, soon replaced Companys the lawyer. This was the Companys who had waved a red and yellow flag from the courthouse balcony in 1931 and proclaimed an independent Republic of Catalunya. The Companys who said, "There is a wild terror raging in fascist-held territory; old people and young children are being murdered; the wounded are being pulled from hospi-

tal beds and killed; works of art are being destroyed. Wherever the fascist passes, nothing blooms again, just as in the days of Attila the Hun. The revolution must evolve; that is the purpose of revolution. The revolutionary must be able to build a new society on the ruins of the old one. If a revolution does not present a strong, responsible, and powerful front, it will die. A divided power cannot stand. At this moment everything must focus on winning the war, but we will not throw our people under tanks as the fascist generals and their foreign partners are doing. We are concerned with every single militiaman, and we treat him with respect, because everyone must share in our victory."

Lluís Companys was the spiritual heir of Catalunya's first president, Francisco Maciá, who died in 1933. Both Maciá and Companys were leaders of *Estat Catala*, the Catalan independence party. Rumors were floating that Catalunya wanted to make a separate peace with General Franco and wanted to secede from Spain, but these rumors existed only as propaganda in the minds of the fascists and the mercenaries they had bought and paid for.

"Spain is fighting for her independence. She is fighting the Moroccans, the Nazis, and the Italian fascists. Catalunya is the heart of antifascism and will always be part of the Spanish Federal Republic. We are a federation and a democracy. Federation and democracy—two sister concepts—only *they* can keep our people free."

Before we met with him, the president's staff had politely informed us how long our audience would last, but we far exceeded our allotted time. As we were leaving, the president showed us the first German rifle captured on the Aragon front. I took this opportunity to ask him a last question about general Catalunyan mobilization.

"We are mobilizing at a feverish pace," he said. "We must answer war with war. We have a new crop of Republican military

officer corps, and we have entrusted our People's Army to them. They are the leaders of the revolution, and there is no doubt they will bring us victory."

THE JEWS OF SPAIN

In the fourteenth century, Barcelona was the leading spiritual center of the Jewish world. Now only vestiges of that once-vibrant Jewish community remain. Prayer shawls, Torah scrolls, chandeliers, gold menorahs, and Hebrew seals dating back to the time when Jews held positions of power, such as royal treasurer or minister of police, are now found only in museums. Jews such as the twelfth-century astronomer and mathematician Abraham bar Hiyya Savasorda ha-Nasi, author of the famed ethical treatise *Hegyon ha-Nefesh* and one such minister of police, now exist only in history books.

In 1820 a house was to be built atop remnants of the former Barcelona Jewish quarter near the current National Palace. During construction a Jewish tombstone, as well as other remnants of the Jewish era, were found among the ruins. The tombstone, embedded in the house's facade, bore the following inscription in Hebrew:

HaKadosh
R' Shmuel
ha-Sardi
N.B.H.

Beneath the tombstone there is another stone etched with a translation of the Hebrew text and a historical reference to the remnants of the Jewish ghetto. It states:

The Holy Rabbi Shemuel ha-Sardi
May His Spirit Always Remain Among the Living

Both the tombstone and the name of the street, El Call, from the Hebrew "kahal," or "community," indicate that a Jewish community and cemetery once existed here. The Inquisition's instruments of torture may still be found at a cathedral that borders El Call. Inquisitors first entered the city in 1487, which ultimately led to the final exile of Barcelona's Jews and the subsequent economic ruin of the city.

In 1492 King Ferdinand and Queen Isabella signed the Edict of Expulsion in Granada. The edict gave Spanish Jews four months to convert to Catholicism, leave Spain, or be killed. No further Jewish life existed in Barcelona until 1931, when Niceto Alcalá-Zamora, himself a descendant of Jews forced to convert to Catholicism, was elected president of the newly proclaimed Spanish Republic. He and professor Don Fernando de los Rios, nicknamed *El Rabino,* or "The Rabbi," formulated the young Republic's new Code of Law, grounded on socialist principles.

Los Rios never denied his Jewish ancestry nor his keen interest in Jewish matters. Four hundred and fifty years after the edict became law in Granada, it was struck from Spain's law books by Don Fernando de los Rios, a man who, like the edict, was born in Granada.

On October 3, 1931, a special legislative assembly, known in Spanish as *Cortes Constituyentes,* was convened to draft the young republic's new constitution. Don Fernando de los Rios addressed the crowd:

"As I present the new laws of Spain, I must express my admi-

ration for the Jewish people and hereby void the edict issued by Ferdinand and Isabella, the Catholic monarchs who locked the doors of our nation to those suffering but admirable people . . ."

The deputies rose from their seats in a standing ovation for the minister of justice; democratic Republican Spain applauded "The Rabbi" of Granada. Los Rios's announcement erased the stain, if not the memory, of this shameful edict. Once the edict was struck, the descendants of Jews exiled from Spain in 1492 began to return.

Los Rios's offer of friendship to the Jews was not merely symbolic. Several weeks after officially voiding the edict, Los Rios traveled to Spanish Morocco and met with community leaders in every city with a Jewish population. In Tétouan, where the Jewish community is now under constant attack by the Falangists, Los Rios's arrival was met with celebration at the Jewish community house.

"Jews of Tétouan! I am as comfortable in your home as I am in my own . . ."

Los Rios was soon appointed minister of education and tasked with eliminating Spain's 70 percent illiteracy rate. He accepted the challenge and, over the course of one year, built six thousand new schools, but in his frantic campaign to create Spanish schools he did not forget the Jews. In Granada he established the Institute for Near Eastern Culture, where Hebrew was part of the curriculum. At the same time he also announced plans to create a similar institution devoted to Jewish culture in Spain.

Two cities—Cordoba, Spain, where the great philosopher Maimonides once lived, and Ceuta, Morocco—competed to be the site of the new academy. Professor Los Rios's happy solution to this rivalry was to establish two institutes: a school of advanced studies to be built in Cordoba, under the supervision of Antonio Jaen, a Freemason, university professor, and socialist deputy. A secondary school would be built in Ceuta under

Don Ignazio Bauer, head of Madrid's Jewish community and the country's leading expert on Spanish Jewish history.

Professor Los Rios's work was interrupted when the reactionary parties won the November 1933 elections, and he was forced to return to his post as university chair and professor. When the Loyalists regained power in 1936, Los Rios returned to government work once more. He was in Paris at the start of the insurrection and was immediately dispatched to Washington, D.C., as Republican Spain's ambassador.

<center>o–o–o–o–o</center>

The Jewish residents from those areas that fell to General Franco fled in fear as soon as the insurrection began. The few Jewish residents residing in Madrid were evacuated. Barcelona is the only Jewish community in Republican Spain, but it is an active community where debates rage and kosher butchers still compete for business.

San Pablo is the main commercial street in the old Barcelona quarter. It is lined with Jewish clothing stores, jewelry stores, even a government-registered kosher butcher shop under the supervision of Rabbi Menachem Kinstlinger, a ritual slaughterer, mohel, teacher, and prayer leader originally from Oswiecim, Poland. He leads services according to both the Sephardi and Ashkenazi rites, delivers homilies in German while officiating weddings, and welcomes with open arms all the Jews of Barcelona's community, whether they are refugees from Germany, Sephardic migrants from Thessaloniki, or recent immigrants from Romania and Poland.

Just how many Jews are there in Barcelona? It's not an easy question. There are an estimated four hundred Jewish families in the city, although only one hundred and fifty take part in community life. For Kinstlinger, the community consists of those sixty families who buy kosher meat from him. In fact, two

kosher butchers compete for community customers: the official *shoykhet*, that is, Rabbi Menachem, and an unlicensed slaughterer with his two strapping young apprentices. But with his musical talents, his stirring prayers, and the support of the community's wealthy—especially its women—Kinstlinger has won the soul of Barcelona Jewry.

Kinstlinger had worked as a religious functionary in the German Jewish community for many years before he fled the country in 1933. Once in Spain he immediately and entirely threw himself into providing for the small Jewish community here. As he will tell you himself, in his first weeks in Spain Rabbi Menachem circumcised a score of already-grown boys, who in the process tore at his beard. But the rabbi is no weakling. He was able to handle the rascals just fine. A real Galitsianer Jew, on holidays Kinstlinger has the bearing and appearance of his region's most celebrated Hasidic rebbes. It's said that the renowned Yiddish actor Maurice Schwartz must have copied Kinstlinger to prepare for his famous performance as the Galician Hasidic Rebbe, Melech of Nyesheve, in the play *Yoshe Kalb.*

<center>○–○–○–○–○</center>

Since the insurrection on July 19, 1936, Shabbos services in Barcelona have been moved into Rabbi Menachem's home, where he established a small prayer house with all the particulars. On the eastern wall, in the place of honor near where the rabbi leads prayers, hangs a reproduction of Szmuel Hirszenberg's painting *The Exile* next to a calendar featuring a portrait of Karl Marx.

Last year they almost reopened the community's synagogue for the High Holidays. The anarchists in charge had not only consented to the resumption of services but offered to send armed guards to protect the worshipers during prayer. The anarchists wanted people to know that if religious groups remained apolitical they would not be persecuted. The community realized,

however, that the synagogue was located near a church that had been torched. Choosing not to offend their Catholic neighbors, services continued in the rabbi's home.

o–o–o–o

I started attending services at Rabbi Menahem's home and was there on the Sabbath before a wedding. The groom was accorded the honor of being called up to the Torah during communal prayers. As per tradition, the bridegroom was pelted with almonds and raisins by the wedding guests. Honey cake and whiskey were served to everyone present after prayers.

I also allowed myself to be invited to the wedding, which occurred the following evening at the rabbi's home. The groom was a German-Jewish refugee and the bride a Galitsianer girl from Boryslav, Poland. Although both the bride and groom were progressive, the wedding was conducted traditionally, as if it were being held in a distinguished rabbi's court in Poland in the good old days.

At the wedding itself, the bride wore a veil and circled the bridegroom seven times. The bridegroom's brand-new, pure white *kitl,* a simple white robe symbolizing purity, was full length. The bride and groom stood under an improvised wedding canopy made from a tallis, a prayer shawl. Rabbi Kinstlinger performed the religious ceremony, sang the appropriate songs, lectured in German, and otherwise showed off his talents. The guests gathered around, holding lit candles, while two elderly ladies performed a traditional *mitsve-tants*, a dance meant to convey blessings on the newlyweds.

o–o–o–o

Barcelona's cemetery is one of the world's most beautiful. Crypts are built into the steps of the rocky, 300-meter-high Montjuïc, known as the "Jewish Hill." Jews were burned at the stake on this

hill during the Inquisition. The crypts are leased for a period of years; if the lease expires and is not renewed, the remains are discarded and the crypt is then re-let to another occupant.

There is an area in Montjuïc reserved for foreigners. The cemetery's few dozen Jewish tombstones are strewn about there, and a stone inscribed with a Star of David may often be found next to a stone bearing a Freemason's triangle. The oldest tombstone dated back to 1921, evidencing the youth of this new Jewish community. Other than the tombstones newly etched by Rabbi Kinstlinger, the Hebrew text engraved onto dozens of older tombstones is error ridden.

Caring for its dead is the primary activity of Barcelona's Jewish community. Many Jewish families cannot afford to pay the annual rent for their family's cemetery crypts, and rental payments account for the greatest part of the Jewish community's budget.

<center>o–o–o–o–o</center>

Soon after Hitler's election, many Jews escaped to Spain. Barcelona's Jewish population grew to six thousand people. After the insurrection, many of those Jews returned to Nazi Germany, where they were deported to concentration camps. Others escaped to London, Paris, and Amsterdam, where they relied on Jewish aid committees for help. Those German Jews were wrong to have fled Republican Spain. Although Jewish life would never return to the bygone illustrious era of ancient Barcelona, Cordoba, Toledo, and Majorca, the Jews who stayed in Spain remained safe.

<center>o–o–o–o–o</center>

In 1905, B.H. was a member of the Kiev branch of the socialist Jewish Labor Bund. When he was seventeen years old, B.H. was exiled to Siberia. From there he escaped to America. For thirty

years he worked as a watch repairman, listening to the monotone ticking of wristwatches. After a fair bit of success, he bought his own jewelry shop. His only concerns were business and family until one day, on the SS *Normandy*, he read about the war in Spain in the ship's newspaper. His dormant revolutionary spirit came alive.

He debarked in Barcelona on a whim, joined the militia, and learned to operate a machine gun. After being quickly promoted, he specialized in repairing the guns' intricate machinery.

"This is a wonderful weapon!" he told me. "Only a watchmaker could understand such an excellent mechanism."

"What about your shop in Chicago?" I asked.

"My wife is a true *eyshes-khayl*, a woman of valor," he said with a smile. "She'll figure it out. I have more important things to worry about here. Machine guns in Spain are more important than watches in Chicago."

Israel B. is an engineer by trade, but his true calling is in philosophy. He showed me a photograph of himself as a young man wearing the long caftan and fur hat typical of Poland's most religious Jews. In Palestine, he worked on a kibbutz for several years, then moved to Paris, where, as a poor student, he studied the philosophy of Spinoza at the Sorbonne and how to build a bridge at the École Polytechnique.

He was not permitted to work in France because he was a foreigner. Unable to teach philosophy or build bridges, he lived in extreme poverty. The only use he had for his drafting board was to prop up his child's cradle. But those days are gone. Israel B. now wears an officer's uniform, and although it doesn't flatter his face or physique, he's been tasked with building fortifications for the Republican Army's front lines in Madrid's center and in Jarama. He also commands the best sapper battalion in the Republic and has received many commendations.

Fanny Schoonheyt is known throughout Spain as Fanny Holandesa, "Dutch Fanny," or "Queen of the Machine Gun."

Officially, she is the only woman who has continued serving in the army. Born into an old and wealthy Jewish-Dutch family whose roots were in Spain, she came to Barcelona as soon as the insurrection began and joined the International Brigades. She was soon promoted to lead a *centuria* on the Aragon front. During the bitter fighting in Huesca, Fanny and her machine gun single-handedly held off a fascist advance on the Huesca Road, protecting the Republican Army as it retreated to a safer location.

Wearing an officer's uniform, complete with trousers, Fanny and her *centuria* captured several towns and villages on the Aragon front. A street was named in her honor in one of these towns. Fanny leads by example. Her bravery was a spur to many men. She is now a political commissar in the International Brigades.

Fanny abstains from everything. She never drinks, she never smokes, she never shows any of the usual female weaknesses. Even so, it's no accident that her name, Schoonheyt, means "beautiful." Fanny even drives her little Ford around all by herself. I once asked her for a lift to the front, but she categorically denied me, saying that she never allows men in her car. She also writes well; her reportage is frequently published in the Spanish press. Several of her articles support the withdrawal of women from the front lines.[7]

Paul (or Peysekh, as he was known in Lodz) sewed trousers in Paris for a living. Because he had no working papers, Paul was in constant hiding from the police. Now this former tailor is a pilot and has logged over fifty hours of flying time in his plane. Although he was in flight school for only three months, his bravery and brilliant control of his machine set him apart from the other pilots. His dogfights in the Madrid skies, battling one-on-one with Nazi flyers, singled him out for a transfer to a squadron of fighter planes on the Aragon front. Having abandoned his sewing machine, to which he was bound for twelve to sixteen hours a

day, for a plane, Paul no longer thinks in earthbound terms. Solid ground beneath his feet bores him. He considers his few days of leave in Barcelona a waste of time and would rather be flying his plane at 400 kilometers per hour. He talks of nothing else but his achievements in the sky, calculating just how many hours it would take to fly to his shtetl back home.

"The best have fallen." I hear these words wherever I am and wherever I go. And indeed many Jewish volunteer soldiers have fallen. Their desperate mothers from all over the world write letters drenched in tears. The languages differ, but the words are the same: "Where is my husband? Where is my son? Where is my brother?" These letters, written in every language, will never be opened. They are buried in a mailroom graveyard, a designated cupboard in the International Brigade's central post office.

My editors and friends forward many of the Yiddish letters to me: "Please tell me the truth, hide nothing," these letters beg. "My son went to Paris to study engineering. To my shock, I received a letter from him from Barcelona. Two months later, I received a letter from Madrid. Since then, nothing. I have enclosed his picture. Perhaps that will make it easier for you to find him. No matter what has happened to him, please tell me the truth."

Another mother writes: "He is our only child. Here is his last address." The address is on the Madrid front lines. "Spare no money. No matter the cost, we will be grateful to pay it, but please, have mercy on us, find out what has happened to our son."

Once, while searching for one of these boys in a hospital, a hand reached out to me from a bandaged body. He spoke in Yiddish, his lips trembling. His eyes misted as he told me stories of battlefield horrors. It amazes me that people so badly injured, so often amputees, are neither bitter nor self-pitying. They do not speak of their own suffering but of their friends with whom they had come to Spain from every corner of the world and who had fallen in battle.

Some of these mothers came to Spain searching for their

boys. A few remain in the hospitals as nurses, finding some solace helping the sons of other mothers.

NEARER TO THE FRONT

Spain is in chaos. There are three capital cities: Madrid, which is under attack; Burgos, General Franco's command center; and Valencia, the Republican government's new headquarters. A 500-kilometer asphalt highway zigzags between Barcelona and Valencia. It cuts through olive gardens, eucalyptus-lined paths, and golden vineyards, curves along the edges of the sea, and then returns to hug the rim of the deep valleys that drop down on the other side of the road.

The villages along this road are tiny fortresses, square houses surrounded by thick stone walls. Every so often a small *palacio* with circular turrets comes into view. Extending into the far distance are the *palacio*'s fields, which are protected by walled gardens. The faraway mountain ranges are limned in blue.

The peasant men walk this highway in their white canvas sandals. Their red or red-black caps announce their political allegiances, as do the women's kerchiefs. Little donkeys pull towering, two-wheeled wagons; oiled tarpaulins protect the produce from spoilage on its way to market. The fields and gardens produce different fruits all year long, and olives are now being harvested. Soon oranges will be ready for picking. The soil is fertile and the foliage beautiful, but massive trucks loaded with ammu-

nition headed toward Madrid's front lines make it impossible to appreciate these bucolic landscapes.

The trucks blast their horns and urge our little Citroën out of their way as they veer around us. Ambulances returning from Madrid, having delivered their cargo of needed medication, race toward us, sirens screaming. Barricades constructed of sandbags and rocks form narrow passageways through which only a single vehicle can pass. These barricades are posted at the entrance and exit of each village, and there is at least one militiaman armed with a hunting rifle standing guard. These guards stop us and demand to see our documents. Many of these peasants are illiterate, so having papers is often not enough to satisfy them; we must also know the day's password. This miracle word that can open these roadway passages was entrusted to our chauffeur, not to us.

Each time we stopped I strained to hear the magic word. At first I could discern only a few syllables, but after ten or so such stops I connected the disparate sounds into one word: "Durruti!"

Durruti was a legendary anarchist terrorist and the brave leader of a military column who left the relative safety of Huesca to rush to Madrid's dangerous front lines. Uttering his name allowed us to continue. Arriving in Tarragona, we drove through gates built by ancient Romans during their triumphant march through Spain. General Franco's legionnaires want to pass through those same gates with the aid of the descendants of those ancient Romans. In response to Franco, the local townspeople have hung a sign written in huge script above the town's entrance: "*No pasarán!*" They shall not pass!

The road straightened as we approached Valencia. Red and white rose bushes lined the roads leading into and out of each town, and their scent filled our vehicle. The speedometer kept creeping up, just like my pulse, 70, 80, 90, 100 kilometers per hour. The colors of twilight deepened from rose to sapphire to dark blue, and then suddenly—pitch black. Sparkling, golden or-

anges flashed among the trees as we sped by.

In our haste to return to Valencia, our driver missed a turn, and the road no longer looked like a major highway. The asphalt turned into a dusty, white-pebbled village path. After driving in the wrong direction for two hours, the driver stopped and admitted he was lost. Seeing some lights in the distance, we drove there to find out where we were.

We arrived in San Jorge at 9 p.m., and the town's old stone houses had long been locked for the night. A towering, half-destroyed wall that had once surrounded and hid the town was its only protection. There were holes in the wall just large enough for a rifle barrel to protrude. Our driver blew the car's horn while we whistled and shouted until finally we heard footsteps. We did not know who was approaching. All we saw were those ever-present white canvas shoes emerging from a dark street. Two wary peasants cradling rifles in their arms approached us. We explained who we were, and they told us we were headed directly toward the Zaragoza fascist front.

Our driver careered the car around in the opposite direction. It took us a while to recover from our close call with death, but to get over our fright we entertained each other with horror stories about similar incidents involving foreign journalists. We even began inventing scenarios of the reception we would have received from the fascists, but our storytelling was cut short when we entered Benicarló, a perfume-producing town, at 11 p.m.

A large crowd was gathered in front of the town hall. Our car was stuck until, upon uttering the magic incantation "foreign correspondents," the crowd parted for us. Pushing through the welter of people and into the building, we discovered a mass of women and children.

These children, 180 in number, were all brought in from Madrid. Their parents had either already fallen on the front or were still there fighting. Many of them were survivors of the vicious Plaza Mayor bombing. They had arrived in the town around

10 p.m. By midnight, the workers of the local perfume factory had adopted them all. The children and their new mothers were greeted with loud cheers of *Salud! Salud!* by the crowd outside.

Never had I seen a more perfect example of the Spanish people's commitment to battling fascism. In all my reading about the Great War, I had never read of an act of such great compassion.

<center>o–o–o–o</center>

As we continued toward Valencia, our car was enveloped by the heady scent of oranges growing in thick groves on both sides of the road. An enormous reflector lit the road every few moments, and a wall of sandbag barricades outlined our route.

"Durruti," our driver yelled as we drove through towns and villages.

Six, five, two, one kilometer more, and I spotted Valencia's defense against airplane attacks—blue lights. Our vehicle's dimmed headlights lit up the gloomy sidewalks. The evening's last tram lumbered through the streets with a blue reflector and shrouded windows, its lazy growl echoing through the dark and dull city.

The press offices at the Presidential Palace buzzed with noise and activity. The office director tasked a militiaman with arranging our night's lodging, and we trekked through the city, wandering from one crammed hotel to the next. Thousands of refugees, evacuees from Madrid and other battleground cities, had jammed into the temporary capital, and finding shelter was close to impossible. We finally found a room with a tiny window in the attic of a seven-story walk-up. All three of us, exhausted, toppled onto a single bed.

<center>o–o–o–o</center>

I shut my eyes; I had no energy; but sleep would not come. Every breath was an effort. I heard every sound, every echo, inside our

little room. Somewhere a clocktower struck 2:30 a.m., and after the brass bells stilled, I heard a single gunshot and the *rat-tat-tat* response of a machine gun. From my time in Barcelona I knew someone was settling a personal debt.

In the morning the sun and the city's noise streamed through the tiny window into the room. I soon found myself being tossed about by the crowd on Plaza Emilio Castelar, the city's central square, named after the president of the First Spanish Republic. Many of Valencia's largest cafés are located on this plaza, and each has its own protective barricade. Valencia had learned the lessons of Madrid and built her defenses.

In the last few weeks, sixty thousand people had migrated to the city, which was already bursting from the half million already there. Valencia's streets were busier than Barcelona's, although Barcelona was home to three times more people. The same refugees who flooded the nationalized hotels made it almost impossible to get a table in the packed cafés. Despite the crowds, the department stores remained elegant. As the capital of Spain's richest province, Valencia displayed its wealth everywhere. The houses, cafés, and municipal institutions were stunning, fully staffed, and tied to old money. Last night's dismal impression created by the scattered, blue-lit lanterns vanished. The city pulsed with life; posters covered every vertical surface, each one more expressive and vibrant than any I had seen in Barcelona.

SPANISH MOTHERS! HURRY YOUR SONS TO THE BATTLEFIELDS!

WOMEN! THE DECIDING BATTLE AGAINST FASCISM IS BEING FOUGHT IN MADRID!

WELCOME THE WOMEN AND CHILDREN OF THE FIGHTING MILITIAMEN INTO YOUR HOMES!

Those sentiments prevailed throughout Valencia and were repeated on her walls. Madrid's energy, as well as her fear of war, lived on in Valencia.

It is Sunday, and as the streets branch farther from the city's center, the mood calms. As in Barcelona, waves of Valencian people flow toward the kiosks that sell tickets to the bullfight. Rafaeli, the only one of Spain's most famous bullfighters to join the Republican cause, steps out to greet the crowd; he is as honored as the most distinguished of Republican generals. Elsewhere a group of children march on Plaza Tetuán. They wear white medical coats and medical corps armbands. Two boys carry a hospital bed covered with silver and gold coins. Passersby toss money at them for the Red Cross.

In the evening the bright streetlamps are extinguished. Last night's sense of dread is returning. Crowded and noisy Valencia is once more turning into a deserted city of blue. At ten minutes to ten the cafés lock their doors, the storefronts' colorful display lights go dark, the trams come less and less often, and the sidewalks are deserted.

o–o–o–o–o

November was at its end, and the sky was clear, cloudless, and so far there were no enemy airplanes in the sky. I entered my hotel, grateful for my little attic room. Not including the garrets, the hotel has 105 guest rooms and usually hosts 200 people. The hotel was currently housing 700 people. Guests overflowed from the rooms, sleeping in corridors and bathrooms. Each day brought an endless stream of people into Valencia escaping from Madrid, and each day the crowd grew larger.

I entered my hotel's overheated dining room. The fourth shift was just sitting down to eat. To accommodate everyone, the hotel had divided lunch into five seatings, from 12 p.m. to 4 p.m. I was assigned to the fifth shift and was seated next to a fifty-year-old grandmother and her six-year-old grandson. Fascists had shot

the boy's father, the famous Spanish avant-garde filmmaker Juan Piqueras, in Seville, where he had the misfortune to be when the insurrection began. The shock of her husband's murder sent the child's mother to a sanatorium. The grandmother's husband was a colonel with the Republican general staff, and he had remained in Madrid.

The child, hungry for affection, latched on to me. He rummaged through my pockets for my fountain pen and notebook and drew fantastical pictures of airplanes and bombs. They were his sole topic of conversation, and he spoke of them incessantly throughout our meals.

<p style="text-align:center">o-o-o-o-o</p>

My hotel was in the very center of Valencia, on Plaza Castelar, under Spain's threatened skies. But I'm not picky. Beneath the restless stars, I slept peacefully.

THE SIRENS OF VALENCIA

I expected Valencia to be bombed at any moment and prepared for the inevitable, as did department store and café owners. By order of the ministry of war, they taped strips of paper on their display windows to prevent the glass panes from shattering. I memorized the addresses of the city's *refugios*, which were printed daily on the front pages of the city's newspapers. I inspected cellars close to my hotel and considered whether they could withstand the impact of a 300-kilogram *Made in Germany* bomb as it rammed through a six-story building. I thought I was ready, but when the lights flashed off at 8 p.m.

We had been sitting at the Lyon d'Or, the old café once frequented by the late director and novelist Vicente Blasco Ibáñez. We spoke of nothing but the bombardments.

We decided that an air raid on Valencia would end in disaster. Soon a million people would be sheltering in the city, crammed into hotels and private homes. Valencia's buildings were old, their cellars useless. Unlike Madrid and Barcelona, where the buildings were enormous and solid and where metro stations provided shelter, Valencia would crumble under the first bombing.

The unrelenting rain had blessed us with a five-day reprieve.

Unfortunately, it was now time for the fascist pilots to resume the festivities. They did not keep us waiting long for their return.

The café door swung open and a woman screamed as she tore into the café, a crying child in her arms. "They're here!" Other terror-stricken people followed her inside. The cafe's overhead lights blinked off, leaving only a tiny corner table lamp glowing near the buffet table.

"No! Get out! There's no cellar here!" the waiter yelled as he threw off his white jacket.

When the streetlights cut out and the sirens shrieked, I was on my feet and running with the rest, my own fear reflected on my colleagues' faces. Remaining in the café was not an option; there was no shelter to be had. We ran from the café looking for the closest cellar. The sirens fell silent. A black shroud enveloped the streets. We were running blind. Stampeding feet echoed on the pavement not too far from us. We followed the sound, hoping for safety.

"Refugio! Refugio!" Voices begged for protection.

I spotted a small kerosene lamp burning at a cellar entrance. We rushed down the stone stairs and the sirens keened once more. The sound of the alarm was haunting, a quiet melancholy wail that strengthened to a roar, then receded to a nervous staccato.

We were in the cellar of a partially built, seven-story building that fronted onto Plaza Castelar. A thousand people pushed themselves inside.

"This is the safest shelter in Valencia," a voice called out.

Men who had been strangers to the frightened women a few moments ago stripped off suit coats and handed them to the women. Women draped their children in men's jackets. These mothers had not thought to bring blankets as they fled their homes. They picked up their half-naked children in the chaos and confusion and ran.

Some of the men started a bonfire from the debris to keep us

warm. We whispered among ourselves as children made sandcastles from abandoned construction supplies.

The hum of voices ceased with every explosion. The alarm dragged on for over an hour but felt endless. Anxiety built as we waited for it to be over. One thought repeated itself in my head: *Let this end! Let this end! Let this end!*

Two pregnant women leaned against the wall opposite me. Feeling sheepish, I stood straighter, and my panic subsided as I observed the unflappable fortitude of the Spaniards. In that moment I understood the self-discipline exercised by the *Madrileños*, those brave citizens of Madrid who had been living under siege since this war began.

I left the safety of the pillars and wandered through the cellar. The women who had been drinking coffee and knitting at the table near us in the café had escaped with their needles and yarn. They now sat on piles of bricks, knitting once more. Older children entertained themselves by building barricades made of sand and playing war, imitating the sound of gunfire: *Bang! Bang! Bang!* Hearing them reminded me of my own childhood during the Great War—the bitter battles my friends and I fought in the ruins of our neighbors' destroyed homes. I remembered long weeks of living in a cold, damp cellar, but no bombs had threatened us.

Shortly before 10 p.m., two hours after the alarm started blaring, the streets were quiet once more. Some brave soul peered out and saw blue lights shining, the signal for all clear. The danger over, we rushed to the exit, eager to breathe fresh air. Outside, small groups of people gathered, each person asking the same question: "Where did the bombs fall? What was destroyed? Who was killed?" No one asked the unspoken question: "When will the planes return?"

My colleagues and I made our way to the Ministry of Foreign Affairs office, where we learned that at 8 p.m. a solitary escadrille plane circled Valencia for a half hour, then departed for Al-

icante. The fascists bombed that doomed city for one and a half hours, but Valencia was spared—this time. As we returned to the city center, people rushed past us toward the blacked-out train station, suitcases and parcels in hand. They joined the crowds already inside the station—everyone wanted to escape Valencia.

I spent a restless night envisioning the specter of airplanes making their first sorties over Valencia, Spain's newly improvised capital city. I woke to the strains of "La Marseillaise" and "The Internationale" playing in the streets. Two thousand experienced French volunteers, mainly soldiers and noncommissioned officers from the last war, were en route to Madrid to support the other International Brigade battalions fighting there. Among the German volunteers, the famous left-wing novelist Gustav Regler could be found.

Shortly after the army trucks carrying the militiamen departed, many evacuees—university professors, intellectuals, writers, artists, and the last group of children who had escaped from Madrid—were sent to different provincial towns and cities for their safety. Meanwhile other trucks poured into Valencia, bringing art objects and valuable books from Spain's National Library, including the first printed edition of *Don Quixote.*

PRIME MINISTER LARGO CABALLERO

Posters of prime minister Largo Caballero are pasted throughout Valencia and the surrounding villages to boost morale. Caballero looks stern—not a hint of a smile. His hands are fisted at his sides; he is Julius Caesar reincarnated, the personification of the people's will, the "Spanish Lenin." He alone can bring victory to the Republican cause. But the Caballero I met was not that man. Even his name was a lie, chosen for its symbolism. His real surname is "Largo," meaning both "big" and "wide." His first name is Francisco. "Caballero" was his mother's maiden name.

An elegantly dressed gentleman with a tiny mustache and a scoliotic spine exited Caballero's office. It was Rosenberg, the Soviet ambassador, leaving an audience with the prime minister. We continued to wait in the large reception area, where a long table laden with crystal glasses and champagne had been set for us. Álvarez del Vayo, the current foreign minister and former journalist, was entertaining us, his glasses edging down his pointed nose and his buck teeth gleaming.

As we enjoyed the buffet and del Vayo's attempts at humor, the door to an adjacent office swung open. A military man wearing a cockade on his chest appeared and invited us to enter.

Tense, we crowded into the office to find a thickset man of average height with deep wrinkles carved into his sallow skin. A few sparse gray hairs still found a home on his otherwise bald head.

This was not the hero of the posters—this was an old man.

Our visit did not please Caballero, but no surprise there. Caballero had deserted the workers of Chamberi, the beleaguered neighborhood of his childhood, where he had been born in a cramped and decrepit hovel. He deserted Madrid in the middle of the night for his gold-flecked Valencia palace.

Prime Minister Caballero was once again receiving visitors, and we assembled for this momentous event. Included among the thirty-two foreign journalists were several Frenchmen, monocles balanced on their noses and oddly barbered beards on their chins. A journalist from a major Parisian newspaper hovered over Caballero and asked him difficult questions in French. A pained smile creased the prime minister's face. He answered in Spanish.

"Madrid will not fall," he said. "The people of Madrid, the people of all Spain, will resist the insurrectionists with all their strength. Madrid is important for morale but has no strategic military importance, so even if Madrid falls, we will continue to fight. Until now we lacked the equipment necessary to wage war, but that is no longer the situation. We now have the means to fight, and so we will fight!"

"What are you planning to do about the Balearic Islands once you achieve victory?" a journalist asked. He was referring to the islands currently occupied by Mussolini's forces.

"We will not cede an inch of our land to anyone!"

"If Franco loses, Germany and Italy may start another world war. Are you prepared to take responsibility for that?"

"If Franco's loss provokes another world war, so be it. We will continue to fight until Franco loses."

"Do you know who dropped the bombs on Plaza Mayor in Madrid and killed all those children?"

"We know exactly who was flying those planes," Caballero

said. "The insurgent Spanish pilots refused to bomb Madrid because their families live there, so the German and Italian pilots did it for them."

Another journalist pulled a packet of photographs from his bag. They were pictures of Madrid's murdered children. The pictures were silently passed from hand to hand around the room.

Finally one journalist asked, "What is your opinion of France?"

"My opinion is," Caballero paused mid-sentence, as if considering possible answers, "that the people of France are with us." And with that diplomatic response, the political portion of our audience was over.

When we returned to the elegant salon, waiters stood ready to pour champagne into crystal glasses arrayed on silver trays. Corks popped, wine poured, but I was not interested in the party atmosphere surrounding the event. I stood apart, observing the person whose name was already legend, Largo Caballero.

Caballero's father was from Toledo and his mother from Guadalajara. They were both impoverished workers and became even more so when, in keeping with Spanish tradition, a new baby arrived every year. Caballero was born in Chamberi, a Madrid suburb, on October 15, 1869. Hoping for a better life, his parents left Madrid for Granada, where, for the first time, the young Francisco met the "Little Holy Brothers," the priests in charge of education.

There were no opportunities for education in Spain other than church-run schools. The teachers of this future "leader of Spanish socialism" were all monks. Little Francisco did not benefit long from the holy teachings. At age eight he left school and was apprenticed to a cardboard box manufacturer. At fourteen he changed jobs and began work as a bookbinder. From there he moved to a rope factory, where he spent his days at a spinning wheel until exhausted. Next he worked as a plasterer, spending his days on the scaffolding around the homes of Madrid's aristo-

crats. He remained in that job until 1904. Thirty-two years later, when he ran for parliament in 1936, his campaign posters identified him as an *estuquista*, a working class plasterer.

Caballero learned the value of education and studied every subject he found to be interesting. In 1890 he joined the Professional Union of Construction Workers. On May 9, 1894, he joined the Socialist Party. An active member and a skilled orator, he was soon propelled to the forefront of the Young Spanish Socialists.

In 1909 Francisco Ferrer was murdered. As head of the modern education movement, he had sought to provide Spanish children with a secular, liberal curriculum as an alternative to the religious dogma taught by the church. Shortly after Ferrer's assassination Caballero organized a massive demonstration in protest. He was arrested for the first time in his life. It would not be the last. From then on, this hot-tempered Socialist leader would be a frequent guest of the Barcelona and Cartegena prison systems.

In 1917 Caballero spent two months in Cárcel Modelo, Madrid's military prison. It was a period of social unrest that saw street wars between the *Confederación Nacional de Trabajo* (CNT) and the *pistoleros*.[8] When the Socialist movement's popularity swept through Spain, Caballero was elected to the Spanish parliament for the first time.

Because of his extensive revolutionary background, his supporters tried to convince the people that he was the "Spanish Lenin." They were unsuccessful. Caballero had tarnished his reputation during General Miguel Primo de Rivera's dictatorship, from 1923 to 1930, by accepting a position in de Rivera's council of state. Caballero defended his actions. He said he accepted the position to enable workers' unions to function during de Rivera's reign. Although supported by many Socialists who believed Caballero wanted to ease the workers' situation, many more saw it as a betrayal.

Caballero's tenure with de Rivera's dictatorship was short lived. Although his popularity was diminished, he slowly regained influence among the people and led the Spanish division of the world's largest labor organizations even before the Republic was established. This self-taught man who spoke no language other than Spanish was soon a member of the oversight committee of the International Workers Bureau in Geneva.

Internal divisions within the Socialist Party intensified soon after the Popular Front won the February 1936 elections. The *moderados*, or moderate wing, headed by Indalecio Prieto, wanted to cooperate with the bourgeois left, but Caballero and his followers wanted a proletarian dictatorship. The conflict between the two groups intensified and soon turned to open hostility. *Claridad*, the newspaper supporting Caballero, led vigorous attacks against the official party outlet, *El Socialista*, Spain's oldest workers' newspaper.

The antagonism between Caballero and Prieto ultimately grew so strong that many thought the Socialist Party would split in two, causing the Popular Front to collapse. Before such a crisis occurred, the insurrectionists attacked. One month later, Caballero was prime minister, war minister, and secretary of the *Unión General de Trabajadores* (UGT). Caballero gave the foreign minister portfolio to his close friend Alvarez del Vayo, but also brought Indelicio Prieto, his chief political opponent, into his cabinet.

I saw these three Spanish leaders interact at a meeting of parliament in Valencia. They sat together in a row, Caballero on the left, Prieto on the right, and del Vayo in between. Caballero stood, lifted his water glass, and transfixed his audience for a half hour with his forceful speech. Caballero was sixty-eight years old, but many men half his age could not have performed as well. He ended his speech to the assembly with: "If the government does not meet the needs of the people, the government must be dissolved!"

He then set his glass down, not having sipped from it once,

and seated himself. Applause filled the room, but Prieto sat quietly, his fingers intertwined on his broad chest. It was a portent. Several weeks later, on May 17, 1937, Caballero lost the support of his ministers and resigned. Dr. Juan Negrin took his place as prime minister. Indelicio Prieto, an outspoken defeatist, became minister of war.

Out of office, Caballero surrounded himself with the usual discontents: anarchists, Trotskyists, and the habitually disgruntled who were unhappy with the Negrin-Prieto regime—the same men who a short time ago had objected to Caballero himself.

THE LEGEND OF DURRUTI

Buenaventura Durruti was considered a revolutionary fanatic by many and was credited with committing many acts of terror that never occurred, or at least not by his hand. Durruti's death signaled the end of Madrid's love affair with romantic anarchism. Most legends surrounding him were fantasy, as he spent much of his life evading the authorities. He was the living incarnation of B. Traven's *The Death Ship*,[9] a vessel not welcome in any port.

Politically savvy, Durruti was the greatest orator among the Spanish anarchist leaders. In 1927, at age twenty-three, he headed the Spanish Syndicalist movement. He also organized the first general strike by railroad workers while working as a mechanic in León province. Armed with only a revolver, he prevented strike-breaking scabs from operating locomotives. As a result, his popularity and influence exploded among anarchists. Constantly pursued by police, he managed to extricate himself from every situation. He moved from one province to the next, his passionate oratory attracting enormous crowds to the anarchist movement.

There is no question that Durruti was behind terrorist acts aimed directly at the Spanish police at the start of the revolution. The Spanish police returned the favor, pursuing a vendetta

against him. In 1927 the Spanish monarchs were invited to the grand opening of a new casino in San Sebastian. The police discovered several cases of explosives hidden in a cave under the building. Although Durruti was at the other end of Spain at the time, he was credited with the assassination attempt. The government placed a bounty on his head, but Durruti escaped from Spain.

The French, Belgian, and Dutch police treated Durruti like a soccer ball; they kicked him from border to border. No one wanted this notorious Spanish terrorist in their midst. In Chile he was sentenced to death for allegedly killing a general. In Argentina he was sentenced to death for committing a bank robbery. In Spain he was sentenced to death on general principles.

Durruti finally settled in Belgium, thanks to the efforts of Belgian socialists. Impoverished, he lived in Brussels for three years under an assumed name, so poor he was forced to eat in public soup kitchens. Once he was discovered living there, he was accused of plotting to assassinate Belgium's King Albert. He was once more on the run.

As soon as the left wing won the Spanish election in 1936, Durruti returned to Spain and threw himself into politics. Having been in chains more than once, he advocated for prison reform, hoping to improve the circumstances of those incarcerated for committing noncapital crimes. He wanted felons to learn a trade and to be paid for the labor they performed while incarcerated. He wanted them to be allowed to leave prison for certain occasions. He understood what it meant to be a prisoner.

<p style="text-align:center">o-o-o-o-o</p>

Durruti, Francisco Ascaso,[10] and Jose García Oliver were Spain's three most famous anarchists and were as close as brothers.[11] The Spanish police considered all three men to be ghosts, vanishing at will. They escaped to Montparnasse, but thanks to the efforts

of the Spanish embassy, they were expelled from France.

As soon as the insurrection began, Durruti was off to the Aragon front, where he headed a division of 15,000 men. He tried to create an anarchist utopia within the region under his control. He eliminated the use of money, introduced barter, and did away with military rank. Military officers were called "war technicians" and were not entitled to any privileges. These "technicians" were required to fulfill the same functions as the enlisted men, such as carrying water and building parapets. Durruti considered military rank a fascist idea and rebuked both the socialists and the Loyalists for maintaining titles within the military.

During his four months in Aragon, Durruti's attitude evolved, and he distanced himself from anarchist romanticism. He insisted on discipline, called for the unification of military command, and imposed harsh punishments on those who terrorized the frontline population. Some resented Durruti's cooperation with the government and his demand for discipline and unity.

His enthusiasm for trading factory-made items for wheat soon waned when he realized the difficulty inherent in such an exchange program. He loosened some restrictions and permitted the payment of cash bonuses, ultimately permitting pesetas to circulate once again.

Durruti was the leader of the largest anarchist division in the army when he was killed on November 20, 1936, defending Madrid.[12] Ascaso was killed on July 19, 1936, on Las Ramblas in Barcelona. García Oliver, the last of the three, was named justice minister in Caballero's government.

o-o-o-o-o

I saw Durruti on a Sunday, marching at the head of a military division. He held his wrinkled hat in his hand, and a large set of field glasses rested on his chest. The men in their red-black caps strode down Las Ramblas, Barcelona's main avenue, to cheers of

"*Viva!*" from the crowd. A memorial plaque to Ascaso hung near the port, and Durruti halted the division to rest his head against it. Removing the scarf from his neck, he wiped his eyes. This "dangerous terrorist," this broad-backed, stolid mechanic, wept at the site where his friend, Ascaso, had fallen.

When Madrid came under severe attack, Durruti left the relatively quiet Aragon front with a large contingent of men and rode to defend the capital city against the greater threat. Just before leaving for the Madrid front, he said, "When this war ends, I will once more be a mechanic in a factory . . . but if I'm destined to fall at the front, it is my wish to die on Madrid's doorstep."

Death came to him as he wished, while defending Madrid.

Durruti's funeral cortege made its way through the streets of Valencia. The minister of justice, García Oliver, the last of the anarchist trio, marched in front of the hearse that carried Durruti's body. As the crowd spread through Plaza Castelar, a squadron of Republican planes roared above the solemn procession, protecting it from fascist attack.

LUDWIG RENN

As the war continued, new heroes entered the as-yet-unfinished pantheon of martyrs for Spain. Many of these people had evaded death in their homelands but would die on Spanish battlefields.

Guido Picelli, commissar of the Garibaldi battalion, led Italian immigrants in their battle against Mussolini's Flechas Negras division on the Guadalajara front lines; Hans Beimler, the Bavarian peasant leader, led the Thälmann battalion against Hitler's storm troopers on the Jarama front. Although these battles ended in victory for the Loyalists, both Picelli and Beimler fell on Madrid's front lines.

New leaders left their desks and traded in their pencils and pens for rifles and swords. Arnold Vieth von Golßenau, a Saxon nobleman (or as he was better known, Ludwig Renn), was one of these men. He left the Davos mountains where his exhausted body was battling disease and traveled to Madrid's damp mountains to fight the fascist disease intent on destroying Spain's body.

The remarkable life story of this nobleman officer and revolutionary author may seem atypical in a book about the Spanish war. Ludwig Renn's story is the story of the Great War, which, in truth, has lasted from 1914 to this day and has expanded onto the

Iberian Peninsula. Renn symbolized the soldier who never left the barricades and trenches. At first Renn was enthusiastic about battle; seeing war's carnage, he joined the ranks of those who stood in opposition to all war.

My friends and I joined Renn at a small café on Plaça de Catalunya in Barcelona. The place was filled with militiamen conversing in dozens of languages. Trucks filled with armed troops singing fighting songs rolled by the terrace en route to Madrid. In the midst of this pandemonium, Renn described his experiences during the Great War. He had already described these events in his books *Krieg* and *Nachkrieg*, and he told us he planned to write another book about his life after this war ended.

He wore a blue short-sleeved sport shirt, his bony arms bare. We sat and talked over coffee, and he pulled a Hotel Colón notebook from his pocket and read us a poem about Spain he had written that morning. We asked him to continue telling us his life story, and he did so, a bashful and childlike smile on his pale lips.

"As a young officer," he said, "I was good friends with Saxon crown prince Georg, who, after Germany was defeated in the Great War, fell into a deep, spiritual depression and became a monk. But back then, in 1913, we had yet to learn the meaning of war. We knew only that our victory was certain, and we were impatient for it to come. The war finally began in 1914, and I went off as a brave young captain. My enthusiasm evaporated the instant I was on the battlefield."

Renn sipped his *cafecito* and stared pensively at the trucks filled with soldiers rolling by before he continued. "I was shattered by my first glimpse of the battlefield dead. Bodies were strewn about, the stench carried in all directions by the wind. The sight of fattened flies and maggots feasting on what had once been my friends was more than I could stand.

"I was transformed the instant I saw the reality of war's destruction. I was not the only one in my circle whose viewpoint

85

changed because of this experience. Many of my peers were affected by that first battle as well. But those same officers, who opposed the war after the first great battles of 1914, were reactionaries by 1916.

"Why did they change, you ask? Class arrogance. By 1916 opposition to the war was spreading fast among the rank-and-file soldiers. The officer classes considered it beneath their dignity to share the same beliefs as common soldiers. I fulfilled my obligations as an officer, but I was torn. The final assault on my former worldview was the so-called Courses for National Awareness. The army staff instituted these propaganda lectures for its soldiers in 1917, but they had a reverse effect on some of us and caused some soldiers to mutiny. The courses set goals for 'Greater Germany,' and then, one day, we were ordered to invade Belgium.

"After the war ended, I got a position as a captain with the Dresden security police force. It was a paramilitary operation established during the Weimar Republic. I was ordered to open fire on striking workers during a confrontation, and I refused. My military colleagues ostracized me. They considered me a traitor to my class, especially because I was born a nobleman.

"Other than Barbusse's *Under Fire*, which affected me strongly, not much had yet been written about the Great War, and certainly nothing had been written from the German perspective. It was then that I wrote *Krieg*. I wanted to fill the void. To do so I needed to free myself from the old German literary influences, the oppressive, baroque style that encompassed all German literature.

"Vladimir Semenov's novel *Rasplata* was assigned reading for young officers in 1913. As we had just finished our Russian-language requirement, I could read the book in the original Russian. The book shocked me. I was disturbed by his description of the Russian monarchy's disintegration but was impressed with his thorough and vivid description of that war.

"I took Semenov's thorough, sober, and realistic style as a template for my writing style in *Krieg*, but I was also writing ex-

pressionist poetry at the time, which contrasted with my prose style.

"I finished writing *Krieg* in 1924 and was far along in writing *Nachkrieg.* I approached different publishers, to no avail. No one was interested; they felt there was no longer any interest.

"I was estranged from my family and by then had no contact with them," Renn said. "I lived well on my captain's pension and decided to walk all the way to Egypt. I left Germany deeply depressed in autumn 1925. I arrived in Italy after several months and met another lunatic like me in a Roman hostel. Together we left Rome and traveled throughout Italy. We were overwhelmed by the poverty and hunger of the Italian people."

"Who was your travel companion?" I asked with the naive curiosity of a reader of suspenseful novels, devouring each page to learn the hero's destiny.

My question caused Renn to sputter with laughter. "My new friend," Renn said, "was both a shoemaker and fanatic follower of Adolf Hitler, who was considered ludicrous by most people at the time. My friend carried little cards that read *Deutschland erwache*—Germany, awake!—and pasted them on every available surface wherever we went as soon as we got there. The only thing we fought about was my friend's Nazi beliefs. Other than that, he was a fine traveling companion.

"For a while we stayed in a Greek monastery on Mount Oeta near Salonika, then we were off to Constantinople, the Near East, and finally Egypt. I returned alone to Vienna in 1926."

Renn then changed the subject to the Barcelona street battles of July 19, 1936. "I still can't understand how unarmed Spanish workers could not only defend against but subdue an insurgent military unit armed with cannon and machine guns. It defies understanding."

Hans Beimler, who up until that point had sat quietly and listened to Renn's tales, interjected and described what happened on the day of the attempted coup. He told of workers jumping

onto cannons and wrenching them from armed insurgents. "You should have seen the battles that occurred right here, in Plaça de Catalunya, right in front of this very café," Beimler said. "How the women ran directly into machine-gun nests. You had to witness their heroism with your own eyes to believe it."

Renn barely took a breath as Beimler described the insurgency's first days. He then interrogated Beimler about the different battles, but Beimler waved him off and asked him to continue with his story.

"I left my manuscript with a friend in Germany before I set off for Egypt. When I returned, I learned that because of his efforts, *Krieg* had been serialized in a Frankfurt newspaper. Within a few months, the book became a worldwide sensation. As a result, I became the secretary of the Proletarian Writers Union in 1929. Soon afterward, my revised version of *Nachkrieg* was also published.

"My interest in military issues and in the military newspaper *Aufbruch* was renewed. I created a seminar series about the development of military technique beginning with the Swiss wars through the present. As such lectures were illegal, I was arrested toward the end of 1932 but released almost immediately. The Nazis were preparing a far more insidious military adventure.

"On Monday, February 27, 1933, the day of the Reichstag fire,[13] I was arrested once again, together with Carl von Ossietzky.[14] We were incarcerated in Spandau prison until our trial. I was sentenced to thirty months and sent to Bautzen prison for serious offenders. Once there I was put in isolation, but other political prisoners provided me with newspapers and reading material."

"Did you know of the worldwide protests made on your behalf by antifascist intellectuals while you were imprisoned?" I asked.

Renn's eyes lit up. "My friend, the one with whom I wandered around Europe years ago, sent me copies of articles calling for my release that he cut out of Canadian newspapers. Of

course," said Renn, "by that time he was no longer a Nazi. I received many anonymous and signed letters of sympathy and reassurance during this period. One of these unknown supporters was himself arrested and interned in a concentration camp because he supported me."

"Were you treated like Ossietzky?"

"No," Renn said. "I was treated relatively well because they hoped I would come over to their side. They thought I would join them because of my former military career and my aristocratic lineage.

"The Nazis offered me amnesty and a deal. They would return my captain's pension to me if I agreed to meet with Alfred Rosenberg. I refused because such a meeting would have been as unpleasant for Rosenberg as for me.[15]

"In August 1935, the Nazis released me subject to certain conditions—they would reinstate my captain's pension and provide me with papers, allowing me to leave the country. In return, I would meet with the foreign press and tell them that the Nazis hadn't beaten me while I was incarcerated. I told them I would have to decline their offer because although I wasn't beaten, other antifascists hadn't been so fortunate, so any declaration I made would be pure propaganda.

"Even though I refused their offer, they released me anyway. I remained in Germany from August 1935 through February 1936, when I smuggled myself over the border into Switzerland."

At that point our conversation was interrupted by a group of Italian emigrants wanting to speak to Renn. They wanted to know if he had any assignments for them and told him his books were very popular in Italy.

"Yes, I know. I've heard that Mussolini is a fan," Renn said, straight-faced. After everyone laughed at his deadpan delivery, Renn wrote a greeting to the group in Italian. Once they were gone, we asked Renn about his latest book, *Vor großen Wandlungen* (*Before Great Changes*).

"The book is a novel about the early years of Hitler's regime during the Röhm Purge.[16] The heroes are a decent Nazi, a left-leaning officer, a young socialist and his girlfriend, and several anarchists, all of whom are members of the German underground. I describe how some upstanding Nazis develop a sympathy for the Popular Front. The book's characters also include several Jews and a Negro murdered by a Nazi racist. The Negro character grew up in a German village and had never met another Negro in his life."

"How long did it take to write this book?"

"Six weeks."

"That fast?"

"It took me several years to write *Krieg*, my first book, but events in Spain provided the impetus for this latest book. I wanted to finish it quickly so I could join the Spanish antifascists."

"How do you plan to help the Republic, as an author or as a soldier?"

"As a soldier!"

Vieth von Golßenau, the infantry captain, used both his rifle and pen as weapons. I would meet him once more. By then he was the commander of the XI International Brigade on the Madrid front, and Hans Beimler was his political commissar.

JULIUS DEUTSCH

Julius Deutsch's arrival in Spain elicited scant enthusiasm from the other German emigrants. He was the leader of a failed revolution, they said. But Mecke, the yellow-bearded Austrian from the Vienna *Schutzbund*, the Social Democrat Republican Defense Association, defended his former leader. Mecke had fought in the Karl Marx House under the personal leadership of Falish, the hero of the Vienna February Revolution. When he arrived in Spain, he signed up to join the *Batalion Malatesta*, the so-called Battalion of Death.[17]

Mecke admired and respected Deutsch. "It's true that Julius Deutsch is the leader of Vienna's failed revolution," he argued, "but he is also the leader of a movement that still continues its underground work in that same Vienna." After Deutsch returned from Madrid, Mecke arranged my meeting with him. He wore civilian clothes and a beret on his bald head. Count Reventlow, his adjutant, wore an officer's uniform. As we spoke, Deutsch drew a map of Madrid's front lines in my notebook.

"Madrid will not fall!" he said. "Madrid will not be defeated despite the murderous bombing! Most important, the people of Madrid are not demoralized. The mood of the people can turn

91

things around. Franco has a colossal war machine, but his supporters cannot be compared to the Loyalists. The Spanish Civil War has become a great disappointment for those who believe in modern warfare technology. It has shown that the machine will not win a war. Only *people* can win it. The ideology that drives the militiamen is mocked by many, but their enthusiasm is far more effective than the disciplined, military temperament. The militiamen have learned the art of war, but the trained Moroccans and the weapons-rich soldiers have not learned the value of enthusiasm. An ordinary Asturian coal miner, Rafael Martí, proved that point when his primitive bombs destroyed tens of modern tanks. The International Brigades have given us more than one philosophy student with greater strategic and military acumen than many of the Spanish generals.

"I believe the Spanish revolution will be successful because it doesn't have the same problems that revolutionaries in other countries brought down upon themselves. The Spanish people continue to work. I saw peasants who carried rifles on their backs as they plowed fields just two kilometers from the front lines. Armed shepherds continue to lead their flocks to pasture, and factories don't just work as usual, they now work double shifts," Deutsch said.

"In all other countries where there has been revolution, the factories came to a complete standstill. Even in Russia, after the victory, it took several years for industry to revive. This has not happened in Spain and will play an important role in the Republic's victory.

"We mock Spain's *mañana* attitude, how everything can wait until tomorrow, and we accuse the Spanish of being disorganized. It may appear so, but in truth, the Spaniards have a wonderful sense of individual initiative.

"They evacuated 200,000 people from Madrid using only automobiles. And they did it within forty-eight hours with no mishap. In no other country would that be possible. Not even

by the most disciplined organizations. Despite the unremitting bombardment, there has not been one day when meat and milk were unavailable. That is an amazing accomplishment."[18]

As expected from an experienced conspirator, Deutsch avoided mentioning his military mission in Spain, although it was his own combat mate who introduced us. Thus limited, we continued discussing the international situation.

"The Spanish war is a rehearsal for the coming European war between the fascist and democratic powers," Deutsch said. "The fascist nations are already unified; Spain is a test case for them. They practice here instead of holding military maneuvers. It's therefore imperative that the international workers' organizations oppose the Fascist International.

"The Spanish Republic's victory"—Deutsch raised his voice— "will postpone the danger of another world war, but in the event the fascists win, Germany will not pass on such an amazing opportunity as a conquered Spain. Hitler will immediately declare war on the French. Bismarck's war against France also began after Germany had assured itself of Spain's friendship, allowing it to establish a base on the Pyrenees front in 1870."

While Deutsch spoke, I considered whether to ask him a potentially painful question about Austria. My sensitivity was unnecessary. When asked, he said: "There is an active underground in Austria, particularly in Vienna. The Socialist Party has eight thousand trustworthy members. Although illegal, we publish the *Arbeiter-Zeitung* daily, as well as twelve other union magazines. Together, they have a circulation of one million."

"What will Austria's position be in the event of another European war?"

"It is senseless to discuss Austria's position because she cannot reach an independent decision. If there is another world war, Austria will be Europe's battlefield. Germany, Italy, and Yugoslavia will march through Austria, and Austria will not have the strength to resist. It will have no choice but to obey the will of the

strongest combatant."

Deutsch concluded, "It is difficult to say what Europe will do, because Europe's fate, whether it be war or peace, will be decided on Spanish battlefields."

THE BASQUES

Of all the political groups that supported the Loyalists, the Basque Catholics were the greatest surprise. The Basques were cut off from the rest of the Republic, but the few messages that got out of Basque country were astonishing. Priests in black cassocks were seen walking on Balboa's streets, and the churches were undamaged. Considering the ravaged churches in Barcelona and Valencia, this was incomprehensible.

Every war correspondent wanted access to Basque country, but the only way into the beleaguered province was by air over fascist-held territory. Our constant requests of the Republican air ministry to be allowed to go there were futile; it was too dangerous. We anxiously awaited Don Manuel de Irujo Ollo, leader of the Basque Nationalist Party and the Basque representative to the central government in Valencia.

We had grown accustomed to seeing ministers in leather jackets or in simple, collarless sport clothes, so the minister's appearance was striking. He wore a black suit, a black tie, and a stiff, white collar. His bearing and solemn face were austere. He looked like a priest on furlough.

Displayed on his office walls and on his desk in the govern-

ment building were pictures of religious scenes. The Basque coat of arms, with its distinctive *Gernikako arbola*—the blessed oak tree of Guernica—and a little statuette of Jesus took pride of place. The American and English journalists in our group showed surprise when told that Ijuro was both a liberal democrat and a practicing Catholic. The Americans could not resist photographing this walking contradiction.

Don Manuel Irujo was a lawyer and the son of Daniel Irujo y Urra, another famous Basque attorney who had defended Arana Goiri, the head of the Basque Nationalist Party. His father had instilled the spirit of Basque nationalism in his son. Although many of Irujo's family members were clergymen, they supported freedom for the persecuted Basque people.

I asked Irujo only one question, and it seemed unlikely that I would be able to crowd in another. Irujo the minister vanished, Irujo the ascetic vanished, and Irujo the jurist had taken their place, prepared for verbal battle.

"In Basque country, we Catholics are the dominant group, but as good Christians, we are tolerant of all people. Christianity cannot support any dictator because Christian teachings express democracy and freedom. We believe that people's minds cannot be changed by force, which is why we do not fight against the communists or the anarchists. We are Loyalists, and we fight for our rights and for our freedom. It is also why we fight against fascist terror and dictatorship.

"Neither the communists nor the anarchists carry much sway over us. They only garner influence when the issue is industrial or agricultural reform. Those reforms do not threaten us because our workers have long controlled production. Their rights are protected under our old traditions.

"The fact," the minister continued, "that we are both democratic and conservative yet have a socialist mindset is not a paradox. In the *Cortes*—that is, in Spanish parliament—our deputies were always considered far right regarding religious issues,

but we were called communists when the issue was social or economic. We are probably the most Christian people in all of Europe. I doubt there are any better Christians than we are. We support an equal division of property and wealth, and we oppose extreme capitalism, which is, in my opinion, contrary to the tenets of my religion.

"Our land is rich, but this civil war will destroy our riches; there will be ruin, hatred, and death. As in every war, both sides will lose, but even if both sides lose, the Republic will succeed. I am convinced of the Republic's victory because the will of the people is behind her."

How prescient were Minister Ijuro's words, and how soon they would come to pass.

"The character of a people," Ijuro said, "is expressed in the way they conduct war. In Spain, we have lost all feelings of humanity. We are no longer human. But war is not conducted with such a burning hatred in Basque country. Neither side is shooting prisoners. Family members of opposition leaders are treated just like other prisoners and are exchanged. My seventy-year-old mother, who was captured in San Sebastian, as well as my sister and sister-in-law were exchanged after three months of incarceration. Unfortunately, my four brothers remain in fascist hands.

"We Basques are outspoken pacifists and committed anti-militarists. But when our freedom is at stake, we will defend ourselves and our beliefs. We will fight alongside the Spanish people, but we also demand our individual rights as Basques.

"We do not seek to extend our message to the other provinces of the Republic. Let Aragon, Castile, Levante, and Catalunya be communist, anarchist, democratic, conservative, or religious. Every province has the right to self-determination, as do we. We Basques will defend our religious convictions. We will resist dictatorship and intolerance. We will fight to protect our freedom. Those are the aspirations that bind us."

I asked him just one more question, and his response was

succinct: "Our attitude toward Jews? As good Christians, we have always felt the need to defend those who are being persecuted. We are nationalists, but only to the extent that we believe in patriotic principles. We condemn all race hatred and small-minded patriotism. Our national anthem makes no mention of the 'children of the Fatherland,' as does the French 'Marsellaise.' Rather, the Basque anthem calls out to all the world's children to come to the *Gernikako arbola,* the mighty oak of Guernica that symbolizes our nation, and to eat from the fruit of our tree. We were the very first in the League of Nations to protest Nazi Germany's persecution of the Jews!"

PRESIDENT AZAÑA'S SPEECH

Fighting continued in Casa del Campo, the university section of the city. The world's tabloids announced General Franco's entry into Madrid. They printed doctored photo montages of Franco entering the Spanish capital on a white horse, trotting down Puerto del Sol, the ruined heart of the city.

These were Madrid's worst days, and it was also the day that President Azaña left his solitary shelter in Montserrat and spoke to the Spanish people from Valencia's capital building. Every Republican faction leader, party minister, party secretary, and all of Madrid's government evacuees were there. Intellectuals, writers, and foreign diplomatic corps all came. A massive crowd gathered on the marble steps outside the building. They all wanted to hear President Azaña's words. By addressing this audience, President Azaña was addressing the world in his official capacity as Spain's president. His speech echoed through the streets, carried on the loudspeakers erected on Plaza Castelar.

President Azaña's speech was impassioned, but beneath his words lay a tone seldom heard from him. Standing behind the podium, he did not gesticulate, but the anger within him was written on his face.

"We Loyalists are fighting for our legal right to lead our nation and for Spain's unification. We are fighting for our independence and our right to decide our own fate, a right that belongs to us alone and no one else. If we were fighting only for communism, then only communists would find themselves on the battlefields; if we were fighting only for syndicalism, then only syndicalists would find themselves on the battlefields; if we were fighting only for right, left, or center republicanism, then only Loyalists would find themselves on the battlefields. But this is not our situation. We are all fighting: the worker, the intellectual, the professor, and the bourgeoisie. Yes, even the bourgeoisie fight, as do the syndicalists. All Spaniards are fighting because we are all one people gathered under the Republican flag."

The room exploded in applause. Even the ministers and party leaders, accustomed to applauding only their own parties, were clapping as loud, as enthusiastically, as the other listeners. Many didn't just applaud; they stood and waved their gold-embroidered handkerchiefs. *"Muy bien! Muy bien!"* they shouted. When the ovations from inside the capital stilled, cheering from the streets was still heard.

Azaña then praised Madrid's defenders. "The most important battle in Spain's history is being fought in Madrid right now," he said. "It will take time, but the moment will come when those who are now suffering in our capital will look back on these tragic days with pride. Their unrelenting opposition to fascism will set an example for Spain's future generations."

Manuel Azaña's unexpected appearance was a direct response to the lies being spread outside the country that he had been arrested by the anarchists. The response to his presence by the other political factions underscored that authority rested with him. He was the nation's president. He would unify the people in their battle against fascism.

Azaña's speech was not the usual prepackaged lecture pre-

pared by a propaganda department. He spoke from his heart. His personal tone and style reflected his true feelings. The spirit and audacity of his words were characteristic of Azaña. He knew his words would elicit anger from the anarchist extremists, but this was not Azaña's first display of courage when standing up for his Republican ideals. Azaña's career had begun with his taking a risk that could have cost him his life.

Until 1931, Manuel Azaña was known only as a writer of dramas, essays, and literary criticism. He presided over the Madrid Ateneum, a private forum created for cultural and scientific debate, and was also the editor of *La Pluma,* a literary journal. He decided to trade his pen for a sword.

On the day the Republic was declared, Azaña, to everyone's surprise, was asked to become minister of war. He appeared at the war ministry alone and introduced himself to the generals. The same generals that had served King Alfonso XIII prior to his abdication accepted him as their leader without opposition. These generals could have had this impudent, literary man arrested, taken into the courtyard, and shot. And Azaña knew it. Azaña's charisma, however, disarmed these fighting men. They accepted his authority, and so it was again today.

There was a celebratory mood in the Capitol building. Azaña, his voice deep, spoke of the Spanish people's heroism. His words came slowly, a tremor in his voice. He did not engage in hyperbole or theatrics, nor did he threaten. His speech was authentic, humane, and poignant.

"Peace will come. Victory will come. But this victory will not be *our* victory. It will be the victory of justice for the Republic. No, it will not be *our* victory, nor the victory of *our* political parties, nor of *our* organizations. It will be the victory of Republican freedom. The victory of the people's rights; the victory of a morality that unites us all. No, it will not be a personal victory, because we suffer as Spaniards, and as Spaniards, we cannot take joy in succeeding over our own brothers."

When President Azaña left the stage, not as many hands clapped as when he first climbed them. Too many hands were wiping away tears.

THE ORANGE GROVES OF VALENCIA

The soil in Valencia is red—as red as the fruits that hang from the branch I hold in my hand. As red as the sun as it descends from a green-tinged sky. There is no dusk or dawn in this land; night falls unnoticed and day bursts into the sky.

Only fifty kilometers away, the soldiers of the Republic and the fascists engage in bitter fighting. Here in Carcagente, between Valencia and Madrid, ripe oranges are picked and new orange trees are planted. The groves are not enclosed. A passerby can satisfy his thirst by stretching out a hand and grabbing a juicy orange off a low-hanging limb. Unlike in Poland, there are no thatched-roof cabins for orchard keepers. No one guards these groves at night. On the road, a caravan of burros strolls by, loaded with large heavy baskets. Their workday is done. The fruit has been delivered to the warehouses.

The civil war has interfered with Spain's normal food supply. The fascists control the land of Extremadura, where flocks of sheep pasture. The Loyalists hold the orange groves of Levante. We are served a tiny bit of meat and a full bowl of assorted fruit for lunch. In Burgos, the fascist capital, the menu is likely reversed. The Loyalists have the advantage because oranges are

easily exported. They can be traded not only for meat but also for cannons and planes. Perhaps that's why so little meat is served.

Orange groves stretch for many kilometers, and the fruit is loaded onto the backs of burros and brought to Carcagente. This is Spain's largest fruit-growing region. Olives, carobs, citrons, figs, and above all oranges grow here. The city exports hundreds of thousands of tons of this bounty to the world.

Twenty thousand people live here; twelve thousand are members of the Carcagente Fruit Association. This is an orange-industry town. Every other residence seems to be its own orange-packing plant. Children use oranges as toys as they play on the vacant streets. Few people venture out during working hours, and the only sound to be heard is the occasional bray of a burro.

This year's harvest is larger than usual, and the machines that wash the oranges in the packaging plants are operating at full capacity. Carcagente maintains the latest in orange-washing equipment, and it delivers six wagonloads of washed oranges daily. The oranges go through a specific process before they are deemed fit to be exported, and not all oranges qualify as beauty contestants.

The oranges are transported by a conveyor belt through a bath of borax solution while two sets of brushes scrub them clean. The conveyor then transports them through a heavy torrent of sawdust as tiny brushes polish them dry. Women sit in rows next to small piles of oranges on the floor. The oranges must pass through eight sets of hands before being crated. Each fruit is measured and then, like a precious gem, encased within a ringlike structure and measured once again. The oranges are then sorted by size; those smaller than fifty millimeters do not qualify for export.

As I stand in the warehouse where the oranges are being sorted, I hear cannonfire echo from the battlefields. The women are oblivious to it. They continue wrapping the oranges in pretty

THE ORANGE GROVES OF VALENCIA

tissue paper imprinted with an image of a woman wearing a traditional lace mantilla. Although the mantilla headscarf tradition has long disappeared from Republican Spain, it remains one of the most popular images for export brands.

Carcagente developed the template for Spain's orange industry: baskets, straw mats to cushion the baskets, crates, and labeled, tissuelike wrapping paper. Five printing presses use engraving plates equipped with miniature type to create labels. Each press produces 35,000 sheets of preprinted paper daily and each sheet contains sixteen labels, enough to wrap a half million oranges per day.

The well-known brands such as Pinar, Masip, and Canielas are still shipped to capitalist countries, but graphic artists are competing to create new, revolutionary labels for the massive amounts of oranges being shipped to the Soviet Union.

The plant's director welcomes me to the sawmill, where lumber is being cut into boards to build new orange crates. "You from Poland?" he asks. Hearing that I am, his eyes twinkle. "We could use some of those Polish forests. Think you could help us get a deal? We'll give you oranges and you give us lumber." I assure him I will look into it.

Spain's largest orange grove, the famous Pinar, is located eight kilometers from Carcagente. It holds 42,000 tree "stands," each stand comprising twenty-five trees. Each tree normally produces twenty *aruba*, or thirteen kilos, but many trees produce over sixty *aruba*. Water runs throughout the fields in manmade irrigation ditches to slake the soil's thirst. The mechanical water delivery system pumps about six thousand liters of water a minute to the Pinar groves.

Pinar, as well as all the other groves, has been nationalized. The one-handed former overseer is still on the job he has held for over forty years. He knows every corner of this vast property. He points out the arbors and the luxurious palace built on top of Carcagente's highest mountain. All the area's groves under culti-

105

vation can be seen from the palace balcony.

Richly designed coaches and automobiles, including a vintage car identified as having been exhibited at the 1898 Paris World's Fair, reside in the palace's garage. Although the vehicles are old, the turbines driving the water to the orange trees are state of the art, manufactured in 1927.

The early crop is being harvested now, but the real harvest won't come until January, when the blood oranges ripen. The Levante oranges were without competition until ten years ago, when Palestine introduced its magnificent fruit to the European market. Spanish growers had no choice—they had to modernize if they were to compete. It was no coincidence that I found the Hebrew-English edition of Palestine's monthly agricultural journal, *Hadar*, on the desks of the agricultural ministries in Valencia when I visited there.

The labor committee's representative was excited to show me the heavily laden trees. They were propped up by supports on all sides so that the weight of the oranges would not topple them.

"We've never had such large oranges or such an abundant harvest," he said.

He broke off a branch on which eleven huge pieces of fruit hung. Handing me this gift, he stretched his arm toward the unending orange forest in the valley and said with bitterness: "The fascist generals want to destroy all this!"

General Queipo de Llano[19] had vowed to destroy this orange treasure of the Levante, just as he had threatened the olive trees of Andalucia. German and Italian pilots had already dropped incendiary bombs on those fields, but the harvest continued.

The peasants planted new trees in the craters dug for them by fascist bombs.

A hundred fatherless families from Madrid have settled in this area. They are the widows and orphans of fallen militiamen. I prayed the terrified children would remain safe here among the green-gold orange trees.

GREETINGS FROM THE "OTHER SIDE"

Blacked-out trains leave Spain's stations only at night. A pinpoint flashlight is used to inspect tickets and documents and wave waiting passengers into waiting carriages. It is well-known that fascist bombers favor train stations and trains, so there can be no light.

The train schedule is consistently inconsistent. Ordinarily, trains run on the hour, but now they leave on an erratic schedule to confuse enemy pilots. Because no one knows the time of departure, not even the conductor, passengers must follow the old schedule. They then wait for several nerve-racking hours in unlit cars. Only when the train begins to move does the mood lighten.

The greater the distance from the station, the more the passengers relax. The carriages are illuminated as the train approaches the seashore. The trains carry wounded militiamen released from frontline hospitals on their way home and refugees from Madrid, traveling with suitcases and children to anywhere.

I strolled through the train's twenty or so cars, meeting people from Madrid to the Pyrenees. They cornered me to tell their stories. Their shared pain united them in a bitter hatred toward the generals who caused their individual tragedies.

A teacher from Tortosa told me he sent his pregnant wife to Majorca in early July to rest. He hasn't heard from her since the insurrection—he is now either a father or a widower. He doesn't know which.

A telegraphist from Murcia sent his six-year-old boy to visit his grandfather in Seville a few days before the insurrection. The fascists shot the grandfather because he was a leader of the local Republican party; the child now lives with his grandmother.

A young anarchist from Barcelona described how on July 19, he threw a hand grenade into a truck transporting enemy soldiers. As the grenade left his hand, he saw his brother on the truck among them. The next day he visited his seriously injured brother in the hospital.

An elderly, shrunken woman from Madrid's old quarter, a black kerchief on her head, tells me how a bomb destroyed a two-story house on the street where she lived, burying all its occupants. When the dead were removed, she says, it was impossible to recognize the victims. Wiping the tears from her eyes she keeps repeating: "My God, when are you going to punish these murderers?"

I noticed a man in a suit with grayish hair and a short beard sitting silently in a window seat opposite me. As time passed, he began assisting me in my conversations with the other passengers, translating idiomatic Spanish expressions into French. Finally he and I started to speak to each other.

"I'm from *the other side*," he said, looking about furtively, as if frightened someone might overhear us. His fear is understandable. To be from "the other side" means to be from fascist-held lands.

"I've been on this side for two weeks, but I'm still afraid to talk to strangers. If you meet strangers while on the side other than yours, it's best to discuss only wine and weather. It's also best not to have any discussions in a foreign language. There are many Frenchmen, Italians, and Germans who are in the service

GREETINGS FROM THE "OTHER SIDE"

of their secret police agencies, and they won't hesitate to report you. The most influential foreigners on the other side are German. The newspaper kiosks over there are filled with German periodicals. Everywhere you go General Franco's portrait hangs beside one of Hitler."

The man was an architect and had worked in Vigo for many years. Because he was a member of a Masonic lodge, the fascists arrested him at the outbreak of hostilities. It was only because of his brother's intervention as a senior leader in the town's fascist organization that he avoided execution. He escaped over the fascist border into the Republican side of Spain.

Caution was this man's second nature. He avoided using the word "fascist" but referred to "them" or "the other side." "They exercise an iron discipline," he said. "The military is everything and everything is for the military. The soldiers greet one another with the Hitler salute, and even the Moroccans address each other with 'Heil Hitler!' All those who return from the front are bedecked in medals. The most grotesque part is that amid all the Catholic symbols on these medals, there is the anti-Catholic swastika dangling among them.

"The Francoist women have returned to wearing the traditional mantilla, while the women of the murdered socialists and Loyalists have had their heads shaved. They're required to appear for inspection every month to make certain their hair is not growing out.

"The standard of living on the other side differs completely from here. The cafés are shut at 8 p.m. each evening. Other than the military, no one is allowed on the streets. Military discipline is maintained, and all orders are executed to the letter. It runs counter to our Spanish way of life but is evidence of the German influence."

The farther we traveled, the more our first-class compartment filled. The militiamen and peasants threw their battered bags onto the plush velvet seats, and this caught my companion's

109

attention. "On the other side *first class* still means *first class*."

After a two-hour nap he awoke and returned to his theme. "You know," he said, bending down to my ear, "in Vigo, we've already celebrated the Nationalist Army's entry into Madrid twice. Madrid's former bishop is living in Vigo now. He participated in the first celebration."

The train traveled at twice its normal speed and flew through the tunnels that run for kilometers throughout the reddish mountains. My neighbor from the "other side" arranged his belongings. He was getting off in Tarragona. I took advantage of these last few moments to learn how a liberal-minded, apolitical Spaniard assesses the current situation.

"The people on the other side keep quiet, and to my mind, that's a bad sign. On this side, all you hear are protests and negative opinions about Franco. Here a victory for the militia is a victory for the people because the people here also fight. Over there the military victories are simply that: a victory for the military. The hinterlands are being terrorized over there, but no one does anything about it. The situation here is tragic. People are killed in Madrid and other cities because of the daily bombing. Over there the atmosphere is sinister and disturbing." His last words were spoken in a hushed tone, but they resonated within me.

He placed his broad-brimmed black hat on his head, picked up his valise, and we both walked into the corridor, pushing our way through to the exit. When the train halted at the platform, I handed him my business card and asked for his in return. He turned pale. Setting down his valise and putting both his hands on my upper arms, he said: "Please pardon me a thousand times, but you don't need to know my name. I know you understand. My brother is still there."

He said goodbye, but he didn't raise his fist as is common here. He merely tipped his hat.

REVOLUTION AND WAR

Every journalist, International Brigade officer, follower of world events, observer from various European countries, and "Second Bureau" spy who relies on "diplomatic" cover, or on specious journalist identification cards, may be found at the little smoke-filled café known as Vodka. People from across the globe, speaking in a babel of languages, pack this café.

The hunchbacked proletarian poet Pascual Pla y Beltrán, known as the "Spanish Gorky," is a frequent visitor. Despite his deformity, he is always surrounded by the prettiest girls of the *Juventudes Socialistas Unificadas,* Unified Socialist Youth (JSU). The son of a washerwoman, he was illiterate until he was twenty years old. Despite this shortcoming, he composed revolutionary verses that were transcribed by his friends and then circulated throughout the workers' groups. Now Beltrán reads his latest poems to his fans every day at Café Vodka.

Ilya Ehrenburg may also be found here. As usual, he is smoking his pipe, making notes on tissue-thin napkins, and looking despondent. André Malraux was one of the first to come to the Vodka dressed as a pilot. Until then military uniforms were rarely seen in Valencia. His appearance gave notice to the journalists and observers that unification of the military had begun.

Posters and radio loudspeakers demand "Discipline!" Differ-

ent political parties have been combined and integrated into military divisions. Germany and Italy have sent seasoned military troops to Franco; the Republican government requires troops of equal skill to oppose them.

The anarchists have opposed this quick militarization and the concomitant development of an officer class. Their opposition resulted in a large group from *Columna de Hierro*, the so-called Iron Column, deserting the front and occupying several villages near Valencia. They secured themselves in burned-out churches, and blood was once more shed in the hinterlands.

The confrontations were tragic, but the war continued without remorse. Those who could not fit into the required need for order, or those who did not want to leave the open city barricades for the safety of the trenches, were "erased."

Sirens shatter the air of the improvised capital with greater frequency. The bellies of houses are ripped open, the bowels crumpled. A million people now inhabit the city, and still the enemy keeps advancing.

The cabarets and their nude dancers are no more. The cafés shut their doors at 8 p.m., but the movie theaters remain open. The feature film is a movie about the battle at Verdun during the Great War. A scene depicts the soldier-hero throwing a grenade under an oncoming tank and stopping it cold. The scene is always met with shouts of "Bravo!" The crowd chants, "Coll! Coll! Coll!" for the heroic Spanish militiaman Antoni Coll Prohens, who stopped four German tanks by the same method on the Madrid front.

Coll! Coll! Coll! This is the same Coll to whom Beltrán the poet dedicated an epic poem that he read aloud to us at Café Vodka. And what of Coll himself? What would he say about all this? We will never know. Coll fell on the Madrid front, a victim of his own heroism.

I believe the film studio may have embellished a bit, but the crowd left the theater uplifted and enthusiastic, whistling "The

Internationale" in the dark streets of Valencia long after the movie had ended.

HEROIC WOMEN

There were women like Federica Montseny, an anarchist who was a teacher before she was appointed health minister. Montseny's ability to organize hospital systems—one of the most important and difficult undertakings in wartime—was miraculous. Dolores Ibárruri, or *La Pasionaria*, as she was better known, had been famous for her inspirational speeches for years. The wife of a simple Asturian coal miner, she was named a communist deputy in 1934. She was a beloved leader, and her name became legend. But these women were part of an older, more revolutionary generation.

On July 19, 1936, however, girls who had never left their homes without a chaperone ran into the streets, grabbed rifles, and hopped on trucks to the front lines. A younger generation of women was coming to the fore, and the role they played in the Spanish Civil War was replete with acts of heroism. These women, among whom were many foreign volunteers, fell on the barricades and in the trenches just as the men did.

Lina Odena was one such woman. She lived with her father, master tailor José Odena, in the "Diagonal," Barcelona's working-class district. A faded sign above José's shop advertised a

man's dress coat. A new marble tablet in memory of Lina Odena, the folk heroine who was born in this house, now hangs there as well.

Lina helped her father sew dress coats for *señoritos* by day. In the evening she read the works of Rosa Luxemburg, Clara Zetkin, and Alexandra Kollontai. She looked pale and delicate, but a powerful inner strength lived inside this anemic little 25-year-old seamstress. She is counted among the greatest of the young Spanish women who took on leadership roles during those tragic July days.

Lina organized the socialist youth in Catalunya and expanded the Popular Front agenda of the Young Workers organization throughout Spain. She was in Almeria on July 19, 1936, where she organized the first "Youth Congress against War and Fascism." The Youth Congress immediately transformed itself into a battalion. Under Lina's leadership, it headed toward besieged Granada. With Lina at its head, the Youth Congress defeated the fascist attack on the city within two days.

A stray bullet did not kill Lina. During the chaos of battle, she found herself surrounded by Falangists. Using the last remaining bullet in her Browning automatic, she shot herself in the head.

Nineteen-year-old Trude Marx arrived in Spain with other German communists who escaped Hitler's Germany. She joined the Loyalists at the start of the insurrection and fell on the Aragon front. Her family has still not been told of her death. Plaintive letters continue to arrive from Nazi Germany addressed to "Trude Marx, Karl Marx barracks."

Margarita Zimbal was a young German artist and daughter of a Nazi professor who taught at the Berlin Academy of Art. She arrived in Spain about the same time as Trude and supported herself by selling her sketches in Barcelona cafés. Margaret and her lover, another German refugee, joined the militia together and were part of the Majorca expedition. He was killed there. To avenge his death, Margarita went to Aragon and was part of the

assault on the Huesca asylum, where fascists had taken refuge. It took a bullet to the heart to stop her.

Lina Odena left final orders to her troops written in blue pencil on the day of her death. Trude Marx left a bloody, bullet-ridden militia identification card. Margarita Zimbal left behind sketches of the front and of Spanish landscapes. These fragments will one day inform future generations of the women who fell in battle for the sake of Republican Spain's freedom.

These women, and many more like them, were caught in the turbulent storm of the revolution. They grabbed a gun and went to war, but their spontaneous heroism is not the sole focus of this story. There were other women—Spanish women who had been enslaved for generations and who finally had had enough. With their actions, they placed themselves in the forefront of the quest for equality by the world's women.

They built the road to freedom during the first few months of the civil war, an emancipation that would have taken them generations to achieve under normal conditions. They freed the average female Republican, who because of the times was soon politically and socially active. These were the hundreds of thousands of women who equated fascism with death, lawlessness, and murder. These mothers of Madrid were now determined antifascists.

<p style="text-align:center">○─○─○─○─○</p>

Things had changed. The romanticism of the revolution was over, replaced by a pitiless war. Men were mobilized once more, and the International Brigade volunteers were officially incorporated into the newly established People's Army. At dawn, the factory workers practiced military drills in the streets. They were taught to shoot and march in military formation. Khaki uniforms replaced canvas trousers and shirts; hard, flat helmets replaced workingmen's caps. The Republican Army grew tougher

HEROIC WOMEN

and more disciplined by the day, and the battalions marched to the front in proper military gear.

With one decree, however, women were removed from the army despite their heroism. They returned from the front lines unhappy and humiliated. Many rebelled against this mandate. They lodged protests with military committees and invoked the names of heroines who had already entered the pantheon of Spanish freedom fighters.

Other women passively accepted their demobilization and allowed themselves to be disarmed. They returned their military identification cards and obediently entered the factories, hospitals, and offices. Many of the women who had been first to fight in the early days of the war and whose heroism far exceeded that of the men conceded they later became a liability and a demoralizing influence. These women were the equal of male fighters on the city barricades; their audacity often outstripped that of the men. The front, however, presented a unique situation. There were nights when not a shot was fired and the damp, uncomfortable foxholes became love nests. Jealousies flared. The few women in the *centurias* were often the cause of conflict.

Despite their demobilization, Spanish women had already earned their place in the history of revolutionary heroism. They discarded the mantilla and became community leaders. These former warriors now staff political offices, but along with lipstick they also carry small revolvers in their elegant purses.

The most notable initiative of the women's movement was the *Agrupación de Mujeres Libres,* the Union of Free Women, an anarchist organization that fought for freedom. Freedom for them did not mean "free love" but rather spiritual and social liberation for all. Huge numbers of people attended the *Mujeres Libres* meetings that were held in the beleaguered towns. The movement soon gained tens of thousands of adherents. Simple women found their voices. These women now walked side by side with men, but they devoted no less energy to enlightening

the women within their own ranks. Although a young organization, *Mujeres Libres* became a powerhouse to be respected.

The group's chief priority was the eradication of prostitution. Outside exploitation of these women by others had ended; the brothel owners had been run off. The girls themselves were now managing these "happy houses." Because the government did nothing to eliminate this scourge, *Mujeres Libres* stepped in.

Posters were pasted in Barcelona, Valencia, and Madrid calling for an end to prostitution. They were intermingled with posters that called for unity and opposition to fascism. These posters, although often melodramatic in tone, were sincere. One depicted a woman saying to a man: "Avoid infectious diseases! They are as lethal as the enemy's bullets." Another poster read: "There are too many red socialist and red-black anarchist kerchiefs in the narrow streets of the red-light districts . . ." A third showed a venomous snake emerging from the breast of a half-naked woman.

These posters covered the walls of the red-light district—some even on the brothel doors themselves—exhorting prostitutes to "free yourself from shame." One read: "Free women! You have the chance for a new life that will allow you to become admirable people and useful members of the community. Come to our schools. You will be taught worthy labor."

The famous Spanish writer Mercedes Comaposada joined the crusade and created a flyer condemning prostitution. She wrote: "The male needs sexual contact, but he does not need sexual disease. Are we truly waiting for a government decree that will brutally suppress prostitution? Waiting is useless. It is not enough to close the brothels; it is not enough to chase the women from their stations on the dark side streets. We must erase the very concept of prostitution from man's soul and mind. When that time comes, the whorehouses will finally be shuttered." Her flyer, as well as flyers calling for mobilization and the evacuation of Madrid, were dropped by plane over the capital.

Mujeres libres wanted their sisters freed from the brothels

HEROIC WOMEN

and placed into community service. Their efforts resulted in over one hundred former prostitutes finding work as washer women in the Republican Army's massive, mechanized laundry in Madrid. These former prostitutes gained self-respect from standing at the same ironing boards as the wives of soldiers, officers, and political activists. They could now refer to themselves as *compañeras*, equal to everyone.

Women wishing to learn a trade could choose to learn dressmaking, telegraph operation, stenography, and tram driving. General education courses were available to them in the evening. These women developed a sense of pride because they were welcome to eat at the same table with everyone else, and they received the same pay as the others.

The government ceded its campaign to eradicate and regulate prostitution to the *Mujeres Libres*. Although the brothels still hadn't been officially abolished, thousands of women were rescued with the help, education, and job opportunities made available to them thanks to *Mujeres Libres* and groups like it.

WHEN WILL THIS END?

They left their homes and olive trees in Galicia, their orange groves in Levante, their hilly pastures in Extremadura. They left all parts of Spain, trying to outrun General Franco's Moroccan and Italian troops. Valencia teemed with refugees. Thousands more were making their way to Barcelona. But for the war, most of these homeless people would have normally gone through life never having seen a locomotive. The burro would have remained their only method of transportation, and Barcelona—that wealthy, festive city—would have remained a fantasy.

But now they sat at long tables in the hallways of a vast sports stadium eating rice and meat. Untouched forks lay at the sides of their metal plates. These Galician and Asturian peasants didn't have the strength to serve themselves with these ornate instruments. They used their knives to peck at the fatty meat. Women without men, children without fathers—each was focused on their own tragedy, their own pain.

The children are noisy. They bang spoons on the table while their mothers, faces prematurely wrinkled, sit quietly. The few men here are all old and gray. Their narrow, sunken cheeks are covered with stubble. Their bony heads are covered by tall, black,

dust-covered hats. These are the Galician peasants, the homeless who came by foot for hundreds of kilometers to escape the fascists. They are illiterate. Politics are unknown to them, but they have learned two words from the political lexicon: "fascism" and "republic." They know that fascism murdered their sons, their fathers, and their husbands. And they know the Republic rescued them and brought them here, to shelter under the roof of the Sports Palace. The Republic has transformed these three thousand unfortunate souls into one family.

Before these people found shelter here, before this war began, Barcelona readied itself for the People's Olympics. The world's proletarian athletes would gather in Barcelona to compete in response to Hitler's racist games to be held in Berlin that same summer. Posters for the Spanish event still decorate the walls and marble chambers, announcing *Olympiada Popular, 19–26 Julio.*

The city was dressed in her party clothes. The road to Montjuïc was filled with signs welcoming the foreign guests. But that evening, even before the colorful lanterns were lit to signal the start of the event, the guests were greeted with the sound of mortars and cannonfire. The rebel officers believed that by starting their revolt on the same night that the *Olympiada* celebrations were to start, the Republican leadership would be confused, and the military coup would succeed.

They were wrong.

Many foreign athletes went directly from the stadium into the militia ranks. They would become the first volunteers of what would become the International Brigades.

Von Viva, the Flemish runner and Antwerp champion, lost his foot on the Aragon front. He had hoped to take first prize at the Spanish Olympiad. Now he is an honorary member of the Barcelona Sports Federation.

A black-framed tablet still hangs in the stadium that lists the names of the *Olympiada* athletes who fell in battle during those

early days. Now the laundry of the homeless hangs on clothes-lines that span the stadium's galleries. The enormous playing field has been divided and planted with blackboards for sixteen groups of children, three hundred in all, who study and play in the arena.

In the middle of this war, the pedagogical dreams of Frederico Ferrar, the great Spanish school reformer murdered at the behest of the monarchy because of his belief in freedom, were finally being realized. Classes are conducted outdoors, one hundred steps from the menacing cannons and anti-aircraft artillery that look out to sea.

The guns bark loud and often, and their sound echoes throughout the empty salons of the stadium, but the stadium's denizens don't flinch. They grew used to the sound of bullets a long time ago. They are, after all, refugees from Irun, Toledo, Badajoz, and Malaga, and the sounds of war hold no surprises for them.

Barcelona is filled with over 200,000 homeless people. The largest collection point is in the now-overflowing Sports Palace. The first refugees were brought here from Irun. The last transport brought refugees from Malaga, their faces still showing signs of exhaustion and terror. The children whose mothers died en route have been adopted by Barcelona families. Women come to the stadium on Sundays, bringing toys for the children and packages for the adults. These same women will often leave hand in hand with a bereft child.

Three thousand beds are arrayed in the corridors, the gymnasium, and beneath the galleries of the sports arena. Some are covered with gray military blankets, others with silken sheets, confiscated from one luxurious bedroom or another. Among the beds, on piles of valises, young women sit and write letters to their men fighting on the front lines. The children play nearby with dolls and toy airplanes, while outside, peasants sit in small groups on the steps near a man they call El Bardo. He is the per-

son who sounds out the words in the newspaper articles to them.

"The Germans! The Italians! The traitorous *Francoistas*!" The peasants repeat the reader's words through narrowed lips. They look down at noisy Barcelona, lying beneath them in the valley, and ask themselves repeatedly, "When will this finally end?"

The food is better here. They sleep on finer beds than they did at home. But they are drawn to the sheep, the flock, and the plow. This noisy city is unfamiliar to them. I walk among them, but the people are reticent, their experiences still too fresh and too raw. When the women are asked about the events that brought them here, they burst into tears and hide their faces in their hands. The men respond in short, clipped sentences.

A sixty-year-old peasant who buried his wife and grandchild on a field near Monda told me what happened in his village of eight hundred souls. They fled in the middle of the night, but at dawn, a fascist plane found them in an open field. The plane dropped low, just above their heads, and machine-gunned them for a half hour. Of the eight hundred villagers, only sixty people survived. One hundred were killed where they stood. The wounded bled out over the course of the day. No help came. It wasn't until evening that a Republican truck arrived and picked up the survivors. The death toll was highest among the children who were riding on the little burros when they were attacked.

El Bardo dropped the newspaper. What more could be said?

I echoed the words of these homeless peasants, "When will this finally end? When?"

But this war was only just beginning.

End of Volume One

Photographs

S. L. Shneiderman was joined in Spain by his wife, Eileen, and by Eileen's brother, the photojournalist David Seymour, also known as "Chim" (1911–1956). One of the most renowned photographers of the twentieth century, Chim earned his reputation with his work on the Spanish Civil War and later founded the Magnum Photos agency together with his colleagues Robert Capa and Henri Cartier-Bresson. His photographs, which appeared in the original Yiddish edition of Shneiderman's book, often reflect the quieter moments of a country in turmoil and the effects of the war on everyday people.

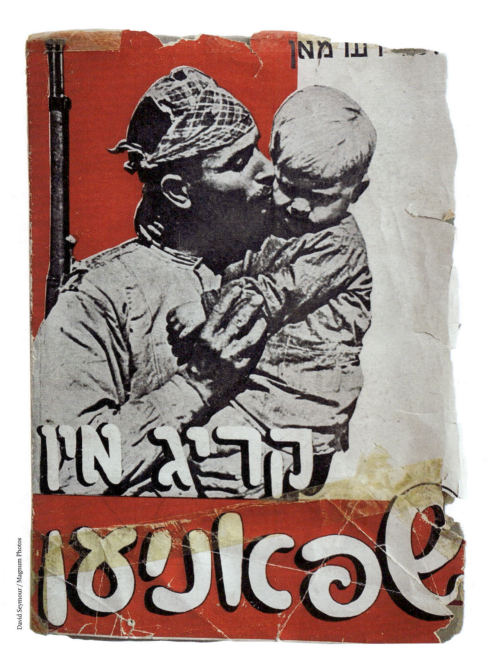

The original cover of S. L. Shneiderman's *Krig in shpanyen (War in Spain)* dramatized the human element of the conflict.

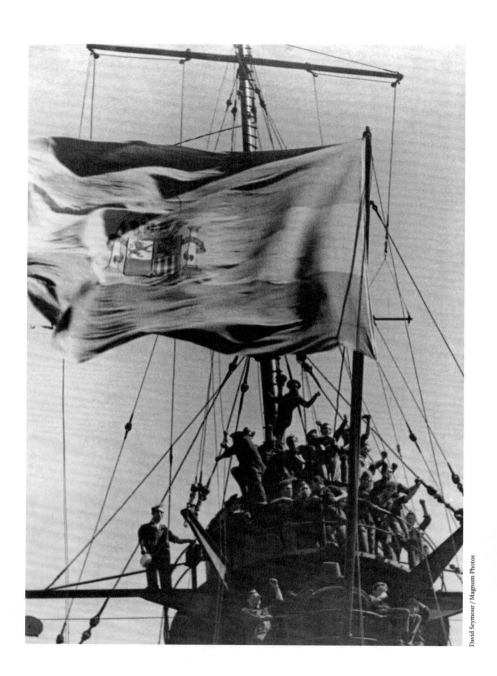

Flying high: At the outset of the war the crew of this heavy cruiser, and others in the Spanish navy, mutinied against their officers to join the Republican side.

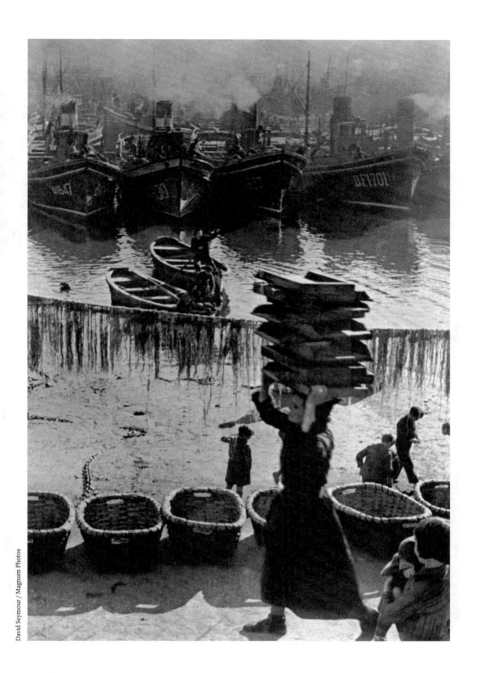

By the shore: During the war even peaceful fishing villages came under fire from enemy warships.

Saved from destruction:
In the towns near the front, militants rescue religious art from threatened churches and monasteries.

Airplane!
An enemy bomber flies over a women's meeting in Barcelona.

David Seymour / Magnum Photos

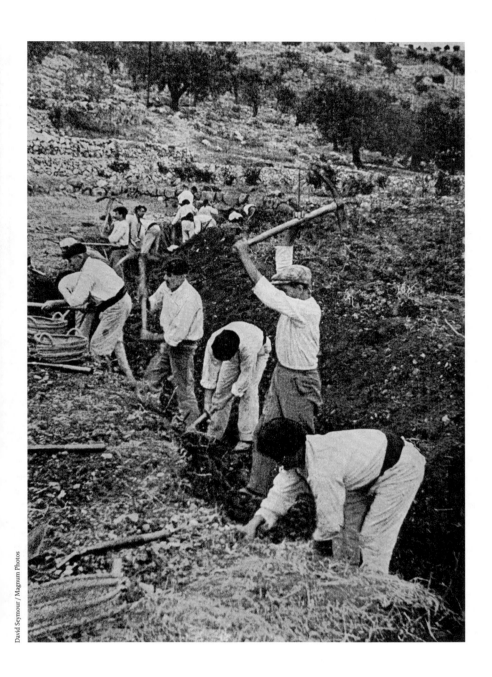

Loyal to the Republic: In the province of Aragon, peasants dig trenches in the stony soil.

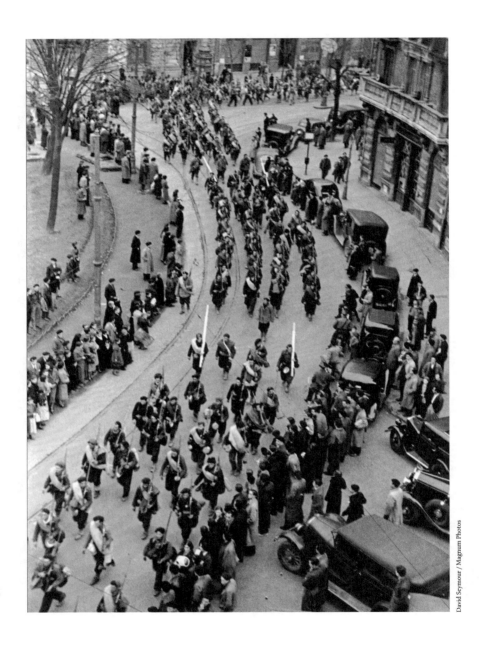

To the front: Battalions march through the streets on their way to the battlefield.

Homeless:
Women and children ask themselves, "When will it finally end?"

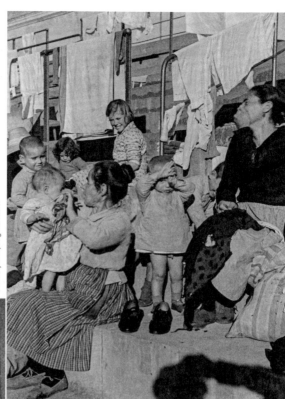

Stay safe!
A train going to the front line bears the initials of the Uníos Hermanos Proletarios (United Proletarian Brothers), or UHP, and the Socialist Unión General de Trabajadores (General Union of Workers), or UGT.

133

The back cover of Shneiderman's book, with the subtitle *Hinterland*, advertised the publisher's address in Warsaw and Shneiderman's own address in Paris.

Endnotes

1 The Ilya Ehrenburg *centuria* was a 100-man division named in honor of Ilya Grigoryevich Ehrenburg, a Soviet writer, historian, journalist, and Bolshevik revolutionary. He was among the most prolific and notable Soviet authors. S. L. Shneiderman wrote his biography in 1968.

2 Shneiderman frequently omitted the surnames and even the first names of those he mentioned in this book. He may have done so because being in Spain was often a crime in these people's home countries. After the war, Shneiderman identified many of these men by their real names.

3 King Alfonso XIII, universally distrusted, held a municipal election on April 12, 1931, hoping for a vote of confidence. It resulted in a landslide for the Loyalists and an ignominious loss for the king. On April 14, the king and his family went into exile, thus ending the Spanish monarchy until 1975, when King Juan Carlos once more took the throne upon Franco's death. Despite the new king's promise to Franco, King Juan Carlos quickly turned Spain toward democracy.

4 Alcalá-Zamora was prime minister of Spain's Second Republic for a brief period of time. He was deposed on a technicality and went into exile in Paris.

5 A freely rotating rotor that provides lift to an aircraft and was a forerunner of the helicopter.

6 Catalonia was allowed to self-govern between 1931 and 1939 although it was still part of Spain. Franco's victory eliminated Catalonia's self-government until 1975, when Franco died. Catalonia was then once more self-governing.

7 Shneiderman's belief in Fanny's virtues may have been misplaced. Photographs exist of Fanny smoking cigarettes, and the identity of her daughter's father has never been revealed. Obviously, she allowed some men into her life.

8 Gunmen hired by employers.

9 Traven's *The Death Ship* is a politically charged novel about life among the downtrodden. It tells the story of an American sailor working illegally on a ship headed for destruction. The book was considered an anarchist novel because of its scathing criticism of bureaucratic authority, nationalism, and abusive labor practices.

10 Ascaso was as much a firebrand as Durruti. They established a libertarian library in Paris financed by their South American bank robberies.

11 Of these three men, only one, Jose Garcia Oliver, survived the Republican defeat by escaping to Sweden. He then moved to Venezuela and finally settled in Mexico.

12 It was rumored that Durruti was assassinated on communist orders (a not-uncommon method of disposing of an inconvenient enemy) or by a *Federación Anarquista Ibérica* (FAI) purist. Others contend it was merely an unfortunate accident.

13 A month after Adolf Hitler was sworn in as chancellor of Germany, the Reichstag, the German parliament, was set ablaze. The Nazis accused the communists of starting the fire and used it as a pretext to claim that communists were plotting against the German government. The event is considered pivotal in the establishment of Nazi Germany because the government conducted mass arrests of communists, including all of Germany's Communist Party parliamentary delegates. With the delegates gone, the Nazi Party went from a plurality to a majority and enabled Hitler to consolidate his power.

14 Ossietzky was a German journalist, pacifist, and recipient of the 1935 Nobel Peace Prize for his work in exposing clandestine German rearmament. He was brutally beaten and starved by Nazi guards throughout his time in the camps. In November 1935, an International Red Cross representative visiting Ossietzky reported that he saw "a trembling, deadly pale 'something,' a creature that appeared to be without feeling, one eye swollen, teeth knocked out, dragging a broken, badly healed leg . . . a human being who had reached the uttermost limits of what could be borne." (Abrams, Irwin [September 1991], *The Multinational Campaign for Carl von Ossietzky*.)

15 Rosenberg authored *The Myth of the Twentieth Century* (1930), a seminal work of Nazi ideology. He is considered one of the premier promulgators of key Nazi ideological creeds, e.g., racial theories, antisemitism, *lebensraum* (room for Aryans to live), abrogation of the Versailles Treaty, opposition to "degenerate" modern art, and hatred and rejection of Christianity.

16 The Röhm Purge, also known as the Night of the Long Knives, was a series of political, extrajudicial executions ordered by Hitler that occurred June 30 through July 2, 1934. They were intended to consolidate his power and alleviate the concerns of the German military about Ernst Röhm's role within the *Sturmabteilung*, the Nazi paramilitary organization. Nazi propaganda described the murders as a preventive measure against an alleged imminent coup by Röhm. The massacre also caused Stalin to start taking Hitler seriously when he saw Hitler's ruthlessness.

17 An Italian anarchist unit that was part of the International Brigades.

18 Women handled food rationing at the time.

19 Queipo de Llano was known as the "Radio General" because he used the radio station *Unión Radio Sevilla* to broadcast sexist and homophobic messages.

Biographies

S. L. SHNEIDERMAN (1906–1996) was a poet, translator, and literary journalist whose coverage of the 1936–39 Spanish Civil War earned him the moniker "the first Yiddish war reporter." With the collaboration of his wife, Eileen, Shneiderman became one of the most influential Yiddish journalists of the century and, after immigrating to the United States in 1940, a pillar of the New York Yiddish literary and journalistic community.

DEBORAH A. GREEN is a native Yiddish speaker and translator, author, and attorney. Her research focuses on Jewish participation in the International Brigades during the Spanish Civil War and with Polish partisan groups during WWII. Her translations of Yiddish letters written by Jewish fighters have been featured in anthologies, magazines, and journals.

The Translator's Acknowledgments

There are many people and organizations I must thank who helped me translate *Krig in Shpanyen*. Foremost is my husband, Dr. Martin B. Green, who continuously encouraged me, entertained me, traveled with me, fed me, and provided me with untold cups of coffee as I struggled to find just the right word to convey the meaning of a multilayered Yiddish word into English. I could not have completed this work without his unwavering support.

My parents, Leon Satz and Sarah Seidler Satz, and the wonderful Workmen Circle Yiddish Schools. Without them I would not have this beautiful and evocative language in my life, and my life would be the poorer for it.

Ben Shneiderman and his sister, Helen Sarid, children of S. L. and Halina Shneiderman, for their confidence in my ability to bring their father's reportage to life and their constant availability by e-mail and telephone as we all struggled through the pandemic.

My dearest friend, Laurie Soff, who graciously undertook the job of copy editor, taught me the proper use of the comma, and eventually acknowledged the singular beauty of the semicolon. She was there for me when Yiddish syntax invaded my English translation. Any errant Yiddishisms are strictly my fault.

Alan Warren, my guide through the Spanish battlefields. Walking through the former Spanish battlefields with him is like walking with a ghost of an International Brigade volunteer; he has

an encyclopedic knowledge of the subject. Anything Alan doesn't know about the Spanish Civil War is not worth knowing. Alan has helped many writers, such as Adam Hochschild, author of *Spain in Our Hearts*; Giles Tremlett, author of *The International Brigades*; Richard Rhodes, author of *Hell and Good Company*; Amanda Vaill, author of *Hotel Florida*; as well as other, lesser-known authors. I am proud he took the time to review and comment on my many drafts and then wrote the foreword to *Journey through the Spanish Civil War*. Any errors are strictly my own.

My brother-in-law and sister-in-law, lawyers Ron and Fran Green, who read my beginning chapters and provided me with necessary feedback for structure and content, especially Fran, who patiently gave me insight into church politics and the life of a nun.

Steve Hirsch, my friend and a member of my writers' critique group. He took the time to argue with me through many drafts of *Journey*. He was usually right.

My new friend Diana Sands, who argued her point of view to me until I conceded. She too was usually right. Thanks, Diana.

YIVO, the Institute for Jewish Research in Manhattan and its amazing collection of Yiddish books, letters, and yellowing newspapers that allowed me to find S. L. Schneiderman's book *Krig in Shpanyen* and become fascinated with the time and place of wartime Spain before I ever expected to be called upon to translate it.

The Yiddish Book Center in Amherst, MA, which digitized *Krig in Shpanyen*, as well as many other books about Jewish participation in the Spanish Civil War, and its academic director Madeleine (Mindl) Cohen, who would later introduce me to the Shneiderman children, Helen Sarid and Ben Shneiderman.

David *Chim* Seymour, whose haunting photographs capture the Spanish Civil War.

And of course, S. L. Shneiderman's reportage and Halina's editing, without whom *Journey through the Spanish Civil War* would not exist.

About White Goat Press

White Goat Press, the Yiddish Book Center's imprint, is committed to bringing newly translated work to the widest readership possible. We publish work in all genres—novels, short stories, drama, poetry, memoirs, essays, reportage, children's literature, plays, and popular fiction, including romance and detective stories.

whitegoatpress.org
The Yiddish Book Center's imprint